ALLEVIATING
prepress
Anxiety

How to Manage Your

PRINT

Projects for

SAVINGS
SCHEDULE
& QUALITY

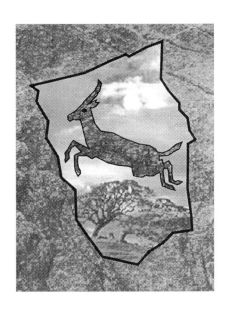

LEAPING ANTELOPE PRODUCTIONS™

Books & MultiMedia for
Learning, Exploring, Accomplishing, Planning

231-C South Whisman Road
Mountain View, CA 94041

1-888-909-LEAP
www.leapingantelope.com

About the Author

Ann Goodheart is a 20-year veteran of the printing and publishing industries. Her career has spanned many facets of communication: teaching, copyediting, developmental editing, writing, graphic design, marketing, sales training and commercial printing. Over the last fourteen years, she has assisted many types of clients, from small businesses to high-tech startups, realize their dreams in print. This book grew out of the everyday challenges of that process.

The following trademarks appear throughout this book: rolodex, QuarkXPress, Adobe PageMaker, Adobe Photoshop, Adobe Illustrator, Pantone Matching System (PMS), Neenah Paper, Color Key, Color Check, Cromacheck, Cromalin, Agfaproof, Matchprint, Windows, Macintosh, Adobe Acrobat, PDF, Iomega, zip, Van Son Inks.

Photographs on pages 51, 54, 55, 60, and 62 were purchased online from www.artville.com, an excellent source for royalty-free art and photos.

Product photography on pages 67, 103, 109 and 111 was provided by William Addison, in-house photographer, Leaping Antelope Productions.

ACKNOWLEDGEMENTS

Words on paper could not possibly express the gratitude I feel for the following individuals who helped to make this book a reality. I am grateful to the many clients and authors I have worked with in both publishing and printing. Your daily challenges inspired me to learn more about the marriage of these two demanding industries.

I am grateful to Rita Bonasera, friend and colleague, who provided emotional support and editorial assistance during the first stages of the book. Special thanks go to David O. Whitten, from the department of Economics at Auburn University, who reviewed the galleys and who wrote the first review of *Alleviating Prepress Anxiety* for Business Library Review International, May 2000, Gordon and Breach Publishing. I posted his review on my bulletin board and it provided inspiration during the final months of book development. I greatly appreciate the dynamic foreword, written by Dr. Susan Fenner, Education and Professional Development Manager, International Association of Administrative Professionals. We share the goal of helping office professionals manage their impossible workloads and ever-changing responsibilities.

Special thanks go to my beautiful mother who inspired me with her love for learning and books, to my fearless father who challenged all my opinions and taught me to pepper everything with common sense, and to my two brilliant sisters, Angela and Gloria, who make me push myself intellectually with every conversation. I also wish to thank my lifelong friend and colleague, Lucinda Peck, who is always there for me, both personally and professionally.

I am eternally grateful to my friend and colleague, Andrea Lower, who helped me take that final leap of faith in getting this book published and into the hands of readers. Her vision, purpose and inner serenity has helped to keep the book, and me, on track during this hectic and challenging process.

ALLEVIATING
prepress
Anxiety

How to Manage Your
PRINT
Projects for

SAVINGS
SCHEDULE
& QUALITY

ANN GOODHEART

Leaping Antelope Productions Books are available for sales promotions, premiums and fund-raising use. Special editions can also be created to specification. For details, contact the publishers at Leaping Antelope Productions, 231-C South Whisman Road, Mountain View, California 94041, toll-free: 1-888-909-LEAP, website: www.leapingantelope.com.

Publisher's Cataloging-in-Publication
(Provided by Quality Books, Inc.)

Goodheart, Ann.
 Alleviating prepress anxiety : how to manage your print projects for savings, schedule and quality / Ann Goodheart. -- 1st ed.
 p. cm.
 Includes bibliographical references and index.
 LCCN: 99-76729
 ISBN: 0-9659222-8-6

 1. Printing--Handbooks, manuals, etc.
2. Printing--Costs. 3. Publishers and publishing--Handbooks, manuals, etc. I. Title.

Z116.G66 2000 686.2
 QBI00-354

to my husband

who makes all my dreams come true
and who participates in my nightmares

TABLE OF CONTENTS

Your message and your audience, 1
Will your readers get the message?, 2
Quantity and budget—a delicate balance, 6
Plan the insert from the onset, 8
I'm late, I'm late for a very important…, 9
Key Terms, 12

Your concept becomes a plan.

The coordinators—printing brokers & ad agencies, 13
The creators—graphic designers, 14
The craftsmen—printers and finishers, 16
The expediters—photocopy shops, 22
The technicians—reprographic services, 23
The assemblers—binderies & mailhouses, 23
Key Terms, 24

You choose your vendors.

A romantic history, 25
Are you my type?, 26
A primer on points and picas or does size matter?, 30
Are we getting closer or are we drifting apart?, 33
Aligning together, 34
Work will keep us together, 36
Romancing the tone, 41
By design, 42
A tryst with technology, 44
Desktop Publishing Resources, 45
Key Terms, 46

You select type & design.

**You work with
photography.**

**You select
papers & colors.**

**You obtain
printing quotes.**

**You design
your future.**

LIST OF TABLES, IN ORDER OF APPEARANCE

LIST OF WAR STORIES, IN ORDER OF APPEARANCE

FOREWORD

Over the years, we have seen many changes in the roles of workers who perform administrative functions and keep businesses on budget, on task, and on time. Our technology-driven work environment has produced many of these changes, defining the way work is done and who does it. Downsizing has eliminated many middle managers and catapulted admins into more responsible positions, with them assuming the tasks that were not deleted with the restructuring. And there is an obvious shift, with corporations now focusing on projects management, teamwork, and business partnering—all requiring new skills to meet these new employer expectations. More often than not, end-product quality control is delegated to the admin coordinator, although the power to implement it may not be explicitly given.

According to recent surveys conducted by IAAP, the desktop power generated by integrated PC applications and now available to most administrative staff means that employers expect well-honed desktop publishing skills. This includes proficiency in writing, editing, graphic design and manipulation of text, scanning of photos and illustrations, inserting charts and logos into documents, sizing visuals, creating digital files to be sent directly to the printer, and even converting graphics to JPEG or GIF for placement into Web sites and subsequent maintenance of site material. This is a far cry from what was expected from employees a few years ago.

How does one master all this and still juggle other job components?

The best solution I have seen to this problem is Ann Goodheart's extraordinary book, *Alleviating Prepress Anxiety: How to Manage Your Print Projects for Savings, Schedule & Quality!* Written by a 20-year veteran who has been there and done it, Ann provides the reader with doable tips on how to choose, negotiate and interface with a printer to get high-quality, on-schedule, cost-effective finished pieces that win high praise

and justifiable recognition. I have yet to see a course or seminar that covers in such great detail all the ins and outs of working with print projects! She covers all the pre-planning steps that make the difference between getting awesome or awful results. She talks about creating dynamite teams that may include ad agencies, creative folks, print craftsmen, expediters and technicians, off-site mailers, and the often hard-to-please manager who came up with the idea and then delegated it because he/she didn't have a clue as to how to get it done.

And the best part (at least the most fun)—are the War Stories and Battle Plans listed throughout the book—telling you how it is (in most offices) and how it could be done (better).

She discusses graphic design and gives you all the tricks of the trade to produce attention-grabbing, easily read, action-oriented material, whether for annual reports, company newsletters, product catalogues, or informational flyers. Also included are the elusive skills most of us tend to learn through trial and error (and mostly the latter), such as the psychology of color (what to use and what to avoid), the impact of fonts (how to get just the right "feel" to your piece), layout formats (that elicit the response you want), and how to get the most from all the software and equipment that sits on your desk or is available through outside sources.

If you are responsible (in any form) for creating copy, editing text, designing print material according to specs, satisfying a work team inside or outside the workplace, selecting paper and colors, preparing a fine-looking internal or mailable piece, while staying within budget and on schedule, then this book is for you!

Alleviating Prepress Anxiety is better than a full-fledged, for-credit course on print and design. It is a quick read, jam packed with easily absorbed and easily applied information that will make you shine as a superstar within your organization and showcase your desktop savvy.

From Idea to Ink

Never argue with
people who buy
ink by the gallon.

Tommy Lasorda

You may not realize how important your corporate position is. After all, you've been given a printing budget and, not only that, you actually have the power to spend it! But before all that power goes to your head remember this—lack of focus can cost thousands of dollars to your company. Careful planning translates into saved time, money, and, eventually, your overall effectiveness in print.

Your message and your audience

So how do you start? You can't decide what to print unless you first decide what your message is and who you want to influence with this particular message. Sound basic? It is, but it's also surprising how frequently this key point is overlooked.

Ask yourself these questions: Who will be reading this piece and why are they reading it? Is it strictly informational? Is it for internal corporate communication or is it needed to attract and reel in new sales? Are the

readers twentysomething or sixtysomething? Are they sophisticated consumers who are choosing between your services and someone else's? Are they environmentally conscious?

Keep asking these questions until you refine your message and your audience. Don't try to accomplish too many goals with one printed piece.

Will your readers get the message?

Now that you've defined and refined your target message and audience, you should consider two important, although very different, factors that affect your printed piece: (1) **how to communicate your message effectively through your selection of words and design** and (2) **how to package your materials so that they are noticed and received either by mail or hand out.**

Both of these factors are crucial to the success of your piece. Consider how long your readers will take to read the piece. For example, if you are designing a poster that will be handed out or displayed in kiosks you should consider how quickly your readers will scan the copy and the design elements. Will your copy grab their attention? Will the design elements you've selected reinforce the message? If there is too much copy or the type is difficult to read from a distance your concept may need revision.

If the information in your printed piece will be referred to time and time again, you should select paper and binding accordingly. For example, a training binder with looseleaf materials for a one-day workshop should be planned very differently than a product binder that is used daily and updated annually.

Remember that abundance of verbiage does not necessarily reflect a clear message. Even long reports should have short, clear summaries. It is important that your message shine through even if the reader does not

2

retain every technical detail. **Review, revise, and reread your copy and have trusted colleagues do the same.** Enlist the support of your in-house editorial staff. There can be no worse failing than spending thousands of dollars on an elaborate design and quality stock only to find you've misspelled the CEO's last name.

Are you sending the same message as your competitors?

Okay, we're not suggesting you plan for a life of corporate espionage here. But, it is foolhardy to prepare important corporate advertising—even your most basic pieces—without a careful scrutiny of what others in the same market are doing.

Your routine mail can be useful in your decision-making process. Start a file of competitive pieces. When you see something innovative make a note of it. Divide your file into these general categories: corporate identity pieces, such as letterhead, envelopes, business cards; flyers or small self-mailers; elaborate product/service brochures; newsletters, both those for internal communication, and those for soft-sell to customers; annual reports; product catalogs; and training materials. Every convention is an item-gathering opportunity.

This file will take you a few minutes to set up but will provide valuable information for selection of type, design, and stock. If you are responsible for designing these pieces it will give you a starting point. If you are hiring a designer it helps you develop criteria to evaluate a portfolio.

WAR STORY: Ellen tells us—as a fledgling designer #1 I brought my brand new business card into a local engineering firm. Much to my dismay, the crusty old engineer I handed it to discarded it saying, "Why'd you make it vertical? It won't fit in the rolodex."

BATTLE PLAN: Plan your marketing pieces for your market!

Do you stand out or do you stick out?

Now that you have a feel for what the competition is doing you want to look similar without getting lost in the crowd. Does this sound impossible? It's difficult at best.

In a sense, along with your competitors, you are a member of an exclusive industry club. You share the same interests, work, associates, and pay scales. But, within this club, some of you are industry leaders. As leaders, you are not looked upon as eccentrics—you blend well enough with others in the club—but your special talents, abilities, and specific interests stand out.

Think of your finished advertising or image pieces in the same way. Positioned in a display with those from your competitors would they say to customers: "This company is in the same industry as the others but their products/services stand out as better quality or more desirable or more specific to the target customer than the others." If the answer is yes, you and your design team are on the right track.

WAR STORY: Kevin tells us—as the financial director of a nonprofit organization I was in charge of producing an annual report. I had produced annual reports for my previous corporate positions many times, so I went about it in the usual fashion. I hired a designer and produced the report on a glossy, slick stock—it was first class all the way. I didn't realize my faux pas until a member of the board of directors called to accuse me of overspending. She was afraid donors would not be responsive after seeing our report. All the nonprofits in the area produced their reports with very simple designs on recycled papers.

BATTLE PLAN: Analyze the marketing pieces of organizations similar to yours to make sure your choices are appropriate.

#2

So kick off your shoes, sit back and learn the art of managing prepress anxiety—from A to Z and beyond. Good luck and have fun designing your future in the process. You just may find that this will be the best money you ever invested.

Susan Fenner, Ph.D.
Manager of Education and Professional Development
International Association of Administrative Professionals

10502 NW Ambassador Dr.
Kansas City MO 64195-0404
Phone: 816.891.6600
Fax: 816.891.9118
E-mail: service@iaap-hq.org
Web site: http://www.iaap-hq.org

International Association of
Administrative Professionals®

About IAAP

The International Association of Administrative Professionals (IAAP) is a nonprofit membership association of approximately 40,000 individuals. Our mission is to:

• Conduct research and track office and workplace trends

• Provide personal, professional, and leadership development opportunities for lifelong learning

• Establish standards for the profession, such as certification and

• Serve as an information clearinghouse on professional issues for employers, employees, educators, trainers, and everyone interested in the administrative profession.

Established in 1942, the organization began as National Secretaries Association (NSA), then became Professional Secretaries International (PSI), and finally changed to International Association of Administrative Professionals in 1998 to reflect the expanding roles and responsibilities of people who do administrative work. We focus on workers in every industry. They may be located in offices, telecommute or choose to be virtual workers, owners of small businesses, outsourced project coordinators, supervisors and/or trainers of clerical staff, or in-house technology specialists.

A needle in a haystack

With your purpose, audience, and a carefully thought out concept of your new printed piece in hand you venture forward to the place all marketing professionals, designers, and printers fear—your local post office. Why do you need to make this trip? First of all, you will never—unless you are a world-class communication wizard—figure out what the local direct mail postal officer is saying you need to do unless you speak with him or her in person. It is a wise idea to visit the actual post office you will use for your mailing. Different offices in different cities do differ in the endless variety of postal rules and their interpretations.

For example, you have a concept for a self-mailer that is a little different in size than the ones you typically see in the mail. A trip to the local post office with a rough mock-up will tell you whether the size is a problem or whether the post office can handle it. **Get a signature from the post office clerk on your mock-up before you go forward with any design concepts.**

The size of your printed piece is only one important factor for mailing. The weights of the paper stock selected and whether you will use business reply are other key points that can affect the safe arrival of the printed piece in your customer's mailbox.

WAR STORY: Gloria tells us—our department created an **#3** 8-page product catalog that was a finished size of 8 1/2 by 11″. After it was mailed, we discovered we could have saved hundreds of dollars on a mailing of 50,000 quantity by folding them down twice to 5 1/2 by 8 1/2″. Our return postcard was an inefficient size as well and we've been left wondering whether valuable orders have been lost in the mail.

BATTLE PLAN: Take a mock-up of your design to the post office BEFORE you finalize your design concept.

Faced with the problems of rising mail costs, a finicky local post office, and customers who are already overladen with daily mail, how can you make sure your piece is not a needle in a haystack? Creative use of words, design, color, and papers helps you stand out even if your budget does not allow the use of nonstandard mailing sizes.

A nationally recognized car company recently sent out a very effective direct mail image campaign targeted to their database of previous buyers. It was just a series of simple, bold, clever statements done on standard size postcards. The postcards each had a bright yellow background with just a few words in large type printed in red. Because of their bright yellow color and few, well-chosen words, the postcards stood out from the endless verbiage and whiteness of the regular mail. This campaign also succeeded because after the third in the series of six postcards the customer recognized the company name and message, which was reinforced with the continued mailings.

> Originality is nothing but judicious imitation.
>
> *Voltaire*

When all else fails, go back to your file of competitors' pieces. Which of these would you read if you were the customer? Which ideas can you imitate or build upon? Which pieces would you pick up and look at if they were strewn around with lots of others on a convention table? We are not suggesting you plagiarize the ideas of others but study them, improve upon them, and learn from their mistakes.

Quantity and budget—a delicate balance

You and your design team arrive at the printers with a rough mock-up of your new identity package and your printer asks you what quantities you would like him to quote. Should you get 1000, 2500, or 5000 letterhead? Before you make even the simplest decision regarding quantity on a

particular piece you should always have your annual global budget in mind. **A simple rule of thumb in printing is that the more quantity you produce the less the unit cost is.** For example, a corporate letterhead designed in two-color might cost 15¢ per unit for a run of 1000 but only 9¢ a unit for a run of 5000 quantity. Because the labor of preparing a job for press does not vary significantly between the two jobs, the cost per unit for the larger run is more efficient, resulting in savings for you as a customer. However, common sense should prevail—you shouldn't produce 5000 letterhead if your phone area code will soon change or if there is any chance your office will move.

It will always be tempting to go with the larger quantity once you see the resulting cost savings. If you go back to press frequently for smaller runs, each time you will pay a significant portion toward set-up charges.

WAR STORY: Tom tells us—the first thing I did in my **#4** new job as marketing coordinator was examine all the purchase orders for the previous two years. I discovered we were ordering about 10,000 sheets of letterhead every quarter. Because the orders were being placed erratically by different departments in our company, we were wasting about $2,000 a year because of poor planning. The quality of our printing was suffering as well—the smaller runs did not always achieve the same color quality because they weren't always run by the same printer. After getting some detailed bids, I am using the same press for larger runs. The results are better and we are saving money we can use for consumer brochures.

BATTLE PLAN: Research your company's buying patterns to determine ways to save money and achieve better results.

Make sure your printer knows if you need a guaranteed quantity. When you order 5000 brochures it is standard practice to deliver as much as 10% under or over that amount. Some presses charge for overage but

many will charge for 5000 pieces even if you receive only 4500. This can be a costly mistake if you have a predetermined mailing list.

If you are in charge of structuring a yearly budget, one of your first steps might be to review the previous year's purchasing data and to organize a list of the various pieces, the budget required for each piece, and the approximate dollars in sales each piece might be expected to generate. For example, if you are spending more money on internal corporate communication than you are to get your message to clients, your budget may need a major overhaul.

WAR STORY: Jeannine tells us—I was really surprised at the discoveries I made by just summarizing a chart of all our printing purchases from last year. We spent over $5,000 on additional rush charges that could have been avoided with better planning. I really expected to see over 75% of our budget allocated for generating new clients. I was surprised and rather alarmed to see that it was less than 25% and, furthermore, we didn't have a clue as to which pieces had been effective for us! This year every piece will have a code customers must give before they can order from us, then I can gauge which pieces are effective.

#5

BATTLE PLAN: Attach the largest budgets to the printing projects with the most important functions.

Plan the insert from the onset

Don't forget to factor in mailing services if you are planning to use them. Many mailhouses use a combination of handwork and machine work to complete their jobs. As you would expect, for the most part machine work is less expensive than handwork. By bringing a sample of the different paper stocks and sizes you are planning to use, you can uncover

any difficulties with assembly, sealing, labeling or packaging. If you are using a database of mailing labels from an in-house company source or a secondary outside service, find out how the labels are organized. Most mailing services charge a sort-tie-stack fee based on how they package bundles for the post office. The way the labels are organized and the types of labels affect these costs as well as the schedule.

WAR STORY: Felipe tells us—I ordered sticky-back labels **#6** for a direct-mail piece instead of cheshire labels available on computer paper. I didn't realize there was a problem until the mailhouse called. Their machines couldn't handle the sticky-back labels, so the job had to be done by hand. The price was 40% more, plus it took an extra week to get it to the post office!

BATTLE PLAN: Obtain specifications from your mailhouse for the most cost-effective labels and databases for mailings.

A common mistake is not allowing for the size differential needed to make inserts work effectively. You can easily see this problem by inserting an 8 1/2 by 11″ order form into a catalog that is the same finished size. The order form won't fit without sticking outside the edges of the catalog. Attractive, isn't it?

I'm late, I'm late for a very important. . .

What may be done at any time will be done at no time.

Scottish proverb

It is unfortunately the fate of printers and mailing services everywhere that they happen to be at the end of the long process of getting a project to print. Customers frequently do not plan enough time for their projects. In this age of high-tech gadgetry and express services the modern printer is constantly asked to squeeze days and weeks out of the printing schedule. And printers do this on a regular basis. But just

remember if you are the ugly stepsister who constantly squeezes a size-10 foot into a size-6 shoe you probably won't end up with Prince Charming! Printing is a manufacturing process and when you hurry manufacturing you frequently suffer loss of quality.

A local printer once advertised: "Excellent quality, quick turnaround, and low cost; take two and call me in the morning." Customers want all their printing to satisfy these three requirements; it's rarely possible. By being reasonable about scheduling and clear in your communication with your printer, you can insure a good working relationship that will translate into quality service and savings to you.

Deadlines are important and they provide an impetus to get people moving, but if important dates are not planned with people and emergency situations in mind they frequently backfire. **Communication is the key in achieving success with scheduling.**

Start by talking to the writers, editors, and designers involved in your project. Draw up a chart showing estimated times of completion for each of these activities. Allow time for several stages of proofing and reworking of the type and design. Once you've done this, and you have a preliminary concept for your project, you can proceed to get bids and estimated times of delivery from different printers. A one-page flyer might go from concept to completion in less than two weeks, whereas a catalog or annual report might take anywhere from eight to twenty weeks.

It's always a good idea to plan backwards from the date a particular piece is needed. For example, if you need a catalog for a convention on June 10th, you should allow at least a four-week cycle for printing and packaging for shipment, a four- to six-week cycle for typesetting and design and the same for writing and editing. You should be planning your catalog in early February.

The following chart is a quick summary of the factors to consider when planning your printing project.

PLANNING YOUR PROJECT

Analyze your competition.

Identify your purpose, your message
and your audience.

Plan budget and schedule. Include a time chart showing
the schedule for writing, editing, design, printing and mailing.

Gather data and
write your copy.

Have meetings with
potential designers.

Choose your designer.

Proofread/edit copy before
releasing to designer.

Determine size of mailer.
Bring mock-up to post office.

First draft design complete.
Revise copy/design.

Get bids from printers and
other vendors.

2nd draft design complete.
Revise design if needed.

Select your printer and other
vendors, including mailhouse.

Final output to press.

Coordinate mailhouse.

Printed pieces to mailhouse.

Review project. Did it stay on budget and schedule?
What could be improved? Did the project achieve its purpose?

Key Terms

The following key terms are found in this chapter. See the glossary at the back of the book for detailed definitions.

annual global budget (page 7)

cheshire labels (page 9)

color quality (page 7)

corporate identity pieces (page 3)

design (page 3)

design elements (page 2)

direct mail (page 5)

insert (page 8)

mailhouse (page 8)

mock-up (page 5)

proofing (page 10)

run (page 7)

rush charges (page 8)

self-mailers (page 3)

set-up charges (page 7)

soft-sell (page 3)

sort-tie-stack (page 9)

sticky-back labels (page 9)

stock (page 3)

two-color (page 7)

Choosing Players

A team is a team
is a team.
Shakespeare said
that many times.

Dan Devine

Your goals, game strategy, and "playbook" of competitive materials have been prepared for action. But, without the right team members, your concept will never make a winning touchdown.

Choosing players requires sound judgment and a strong sense of how people's strengths can be mixed together to create greatness. The good news is there are many talented people who would love to join your team.

The coordinators——printing brokers & ad agencies

Printing brokers are independent contractors who earn a living by coordinating printing. Because they have experience working with many different kinds of printers, their strengths lie in being able to match projects with the printers best suited for those projects. The large volume of printing they coordinate every day means they can frequently produce projects for less money and pass those savings along to you, their client. Their profits come from markups on printing so they have a vested

interest in whether the printed piece meets your satisfaction—if it doesn't you won't be rehiring them!

When you select a printing broker for your team, you are essentially hiring a manager. Obtaining references from the broker's other clients will be critical in your hiring decision. The nature and scope of projects your broker has coordinated and whether he or she is familiar with your industry will be determining factors as well.

If you need help planning an advertising campaign that requires more than just print media, you may want to contract the services of an ad agency. Advertising agencies consist of copywriters, graphic artists, production coordinators, and free-lancers. They create a sales message for you and then plan a global campaign to get your message out to the public by every available means—in print, by broadcast, on billboards, and even via the internet!

Hiring an advertising agency is similar to becoming the owner of a football team. You pay BIG dollars for diversity of talent, but you still need to manage that talent effectively to get the projected pay-off. Review portfolios and client references from several agencies before making your hiring decision.

The creators—graphic designers

Style is a simple way of saying complicated things.
Jean Cocteau

Graphic designers are artists who specialize in preparing creative, reproducible designs that convey commercial messages. The well-versed designer can support your concept by producing striking, memorable images that communicate your message.

creative, communicative, commercially attuned, cost conscious

Because the graphic designer you select can make or break your project as well as your piggy bank, it's important to do a careful job of screening potential applicants. Does the designer's style and portfolio match your company's philosophy and look? Does this applicant display an in-depth knowledge of which types of projects are achievable on different printing presses? Do the designer's current clients attest to his or her ability to respond to deadlines and to keep within original price estimates?

If you have the budget, you might consider having several designers prepare samples based on one test concept. Several renderings of the same concept by different designers can tell you a great deal about which designer might be the best match for you and your company.

WAR STORY: Megan tells us—I hired a graphic designer **#7** with a fabulous portfolio to work on one of my first projects as a marketing assistant. Her mechanicals for our corporate brochure looked great and I was very excited about seeing the final printed pieces. Well, I got her bill and it was twice the amount I was expecting! The project came apart at the seams once I took the negatives over to the different printing companies I was considering for the print work. All of them said the trapping on the job wasn't handled correctly and it would be virtually impossible to achieve the expected results on press without fixing the errors in the films first.

BATTLE PLAN: Always request price estimates in writing. Also, make sure from the onset, again in writing, that no dollar amounts will be authorized from your company without advance clearance for charges that vary from the original estimate. Get your designer and printer together early in the process to ward off any production problems or concerns.

The craftsmen——printers and finishers

Miracles sometimes occur,
but one has to work terribly hard for them.

Chaim Weizmann

Unless your company is a start-up or has very limited printing needs, it would be unusual to be able to find one printer who can handle proficiently all the diverse printing projects you will coordinate throughout the year. Not all print shops are the same—they vary greatly in the types of projects they handle regularly, turnaround time, price, service, and, perhaps most importantly, level of quality. Some print shops offer in-house graphic design, typography and prepress services as well as printing. Some offer very specialized types of printing, such as continuous forms or labels. Still others may have their own in-house bindery equipment or mailing services.

WAR STORY: Cindy tells us—my local print shop had #8 been handling all my needs for corporate stationery for six months and I was really happy with the finished pieces on a consistent basis. Then, I brought them a new advertising piece to do—a jazzy flyer with a large bleed of ink on a coated paper. The results were unexpectedly awful. The ink coverage was really inconsistent and when I rubbed the surface slightly the ink actually came off!

BATTLE PLAN: Don't assume one printer will be able to handle all types of printing projects. Match different printers to the types of projects they specialize in. Always get representative samples of completed work and references from other clients before making a decision about which printer is best suited for your job. Put your expectations concerning quality in writing and ask your printer to review it with you.

It isn't necessary for you to know all about the different types of press equipment for you to make a wise decision about which printer best fits your particular job. The following table shows the major issues you need to consider on a continuum from easiest to most complicated.

TABLE 2-1: MAJOR ISSUES TO CONSIDER WHEN CHOOSING PRINTERS

	Easiest ⟷ **Most complicated**			
ink coverage:	light ink coverage			heavy ink coverage
format:	smaller than 11 x 17″			larger than 11 x 17″
number of pages:	single sheet			multi-page
number of colors:	1-2 color	3-color	process color	process + PMS
weight of stock	bond paper	text weight		cover weight
type of stock	uncoated			coated

What is offset lithography?

Offset lithography, commonly referred to as offset printing, is the most popular commercial printing method. On an offset press, the image is offset from the plate to the blanket, then from the blanket to the paper.

17

This process makes it possible for the printer to use plates that read from left to right just like the finished image. There are basically two types of offset presses—sheet-fed and web. Sheet-fed presses vary in size from 11 x 17″ to 55 x 78″ format. In general, the larger the sheet size the more ink coverage the press can handle. Web presses print rolls of paper. Most web presses yield either an 8-page or a 16-page 8 1/2 x 11″ booklet folded from one sheet cut from the roll after printing.

Table 2-2 is a thumbnail summary matching types of jobs to types of presses. There are no specific guidelines that can tell you where the perfect cutoff point is for one type of press versus another. For example, if you need 100,000 posters that are 11 x 17″ finished size, both large sheet-fed presses and web presses might be able to offer you competitive prices.

dimension, dazzle, and die cut

If you close your eyes and someone hands you a brochure that has been offset printed, you can't tell by touching the surface where the ink ends and the background paper emerges. But, you *can* feel an embossed or foiled surface because these finishing touches add a dimension of depth to printed pieces. With embossing, the paper or other surface is pressed with special dies yielding an image that is higher than the paper. For example, a sheet of letterhead might be offset printed with a corporate logo and then the logo might also be embossed so it stands up on the paper for an interesting effect.

Foil stamping is a heat process that uses a heated die to transfer a pigment to the paper's surface. Foil is frequently used to create very shiny gold or silver finishing touches, but it also comes in other colors. The images created with foil are slightly raised above the paper's surface but foiling and embossing can be combined to achieve a more dramatic raised image.

Die cutting creates scores, perforations, and irregular shapes in paper. A custom presentation folder with nonstandard pockets and slits to insert a business card is a good example of a die cut product.

TABLE 2-2: MATCHING JOBS TO PRINTERS				
type of job	**sample quantity/color**	**type of shop**	**type of equipment**	**comments**
business cards letterhead envelopes flyers (*on lightweight stocks*)	500-2,500 1-2 ink colors	quick printers & small commercial presses	small sheet-fed presses	quality varies greatly—check samples copy shops also handle some types of flyers
flyers, brochures on uncoated & coated stocks both text and cover weights *no large blocks or bleeds of color*	2,500-7,500 2-color	quick printers & small commercial presses	small sheet-fed presses up to 12 x 18″ size	coated papers are much more difficult to print than uncoated find out if your printer prints these regularly
brochures, posters with heavy blocks of ink coverage, bleeds larger than 11 x 17″ flat size	10,000 to 100,000 2-color to process color	small to large commercial presses	sheet-fed presses from 12 x 18″ up to 55 x 78″ web presses	large sheet-fed presses handle large blocks of ink coverage, bleeds; webs competitive for some formats
catalogs, books, newsletters, manuals	500 to 10,000	medium to large commercial presses with specialty in multi-page documents	sheet-fed presses from 12 x 18″ up to 55 x 78″ web presses	sheet-fed presses easily handle newsletters, short book runs; webs for longer book runs
continuous roll labels, forms or checks	1,000 to 100,000	specialty print shop	continuous form press	commercial shops handle these jobs by sending them to specialty shops that print for the trade
printing on plastic, such as 3-ring binders	50 to 500	specialty print shop	silk screen printing	

19

Embossing, foil stamping and die cutting are all achieved using letterpresses. The work requires artistry as well as an understanding of printing technology.

WAR STORY: Harry tells us—a large portion of my #9 company's printing needs involve presentation folders and collateral for proposals we're preparing for our own clients. In preparation for a folder job I had some large sheets of gloss cover stock offset printed with a process color image of an architectural model. The job was for an important proposal so we decided to spend extra budget to get some silver foiling of our corporate logo over the preprinted photo before the sheets were converted to folders.

Unfortunately, the finishing company that we hired to do the silver foiling had a problem with the job. The foil blistered because of the type of varnish the printer had used over the photo image. Since the problem was not due to either vendor's negligence, we had to have the piece reprinted at our cost.

BATTLE PLAN: Make sure your vendors communicate with each other to ensure that planned specifications are workable for all parties. Encourage them to communicate problem areas well in advance.

As you choose the printers and finishers who will be members of your team, remember that having gourmet pots and pans in your kitchen doesn't necessarily mean you are Julia Child. Matching equipment to jobs is only part of the qualifying process. The skill of the operator is the overriding factor that decides whether you end up with a memorable meal or scraps for the compost pile!

Table 2-3 summarizes questions you should consider as you choose the printers and finishers for your project. To simplify this table we've used "printers" for both printers and finishers and "he" for both he and she.

20

TABLE 2-3: PRINTER EVALUATION CHECKLIST

✓ **responsiveness** How quickly does your printer provide a quote? Is it professionally presented? Is your printer able to provide you with clear technical information when you need it? Can your printer estimate the schedule needed for a particular job? Can he stick to agreed upon deadlines consistently? Is he communicative about problems regarding schedule, cost, or quality?

✓ **quality** Does the quality of the printer's samples meet your expectations? Is the color consistent across the sheet? Is the ink laydown smooth? Are photos sharp with good contrast? If you have quality concerns does your printer address these directly? Is he clear about equipment limitations?

✓ **competitiveness** Do the printer's quotes fall within the range of those from local competitors? Is he occasionally willing to provide you with additional services for a nominal cost in order to retain your long term good will and business?

✓ **flexibility** Can your printer respond to last minute problems gracefully? Is he willing to suggest other options when your budget is tight for a particular job?

✓ **on-site inspection** (An on-site inspection can frequently help you determine whether a "low bidder" will handle your job properly or whether a "high bidder" is worth the additional cost.) Is the press shop organized or is it a fire trap? Does the printer offer press proofs for important jobs?

✓ **other services** Does your printer offer other services in addition to offset printing? Does he offer graphic design or typography? Scanning or darkroom services? Finishing or bindery? Pickup? Delivery? Coordination of other vendors including services for the trade only?

21

The expediters——photocopy shops

Photocopying is a heat process. When you make a copy, electrostatic charges are placed on the photocopier's drum in the shape of the original's text or graphics and then toner, which is a powder, sticks to those images and is fused by heat onto the final paper.. Photocopying and offset printing are two divergent technologies that both happen to yield images on paper. Because toner lays down on paper very differently than ink, a photocopied image will not be comparable in quality to an image that has been offset printed. This is especially true where halftones or screened images are used.

Upgraded technology means better copiers are appearing on the market every year. There is no doubt that high volume photocopying has bitten a big chunk out of a market that was formerly the exclusive domain of small offset presses. Informed consumers can use this to their advantage for project planning.

The rule of thumb that the more units you print the less the cost per unit is **not** necessarily true in the world of photocopying. The cost per unit might remain the same whether you run 200 or 2,000 copies of a single sheet. With very small runs, 100 to 500, a photocopier might be the best option because offset printing is not economical nor time efficient for this size run. However, quantities of 1,000 to 5,000 of a single sheet might be just as economical with either a photocopier or an offset printer.

High-tech, computer-driven photocopiers create images repeatedly from their computer memory instead of from a paper original. With traditional photocopying a sheet of paper with pasted-up images frequently needs touch-up or a second generation original so cut marks won't show on the finished copies. With a digital photocopier all the "paste-up" is done on-line with a scanner and the use of page layout programs. The resulting quality is better than traditional photocopying. If you need small runs of a black and white technical manual, with changing information for every 50 sets, a high-tech copier is well suited to your job.

22

The technicians—reprographic services

Reprographic services offer a wide variety of prepress output devices that can assist you for interim stages of a project. They also offer specialty finished products that are difficult or impossible for printers to produce, such as short runs of oversized color posters or sets of oversized architectural blueprints.

Designers use reprographic services to obtain prepress materials. A designer can bring in a computer disk with a final design and obtain linotronic film output which is used to create a final printing plate. A color print or fiery can be output from a first draft design on disk so that a designer can present a preliminary design mock-up to a client.

Printers also use reprographic services for specialty prepress output. For example, many commercial printers produce process color printing but obtain color separation films needed to create the final printing plates from a reprographic service or a color separation house.

The assemblers—binderies & mailhouses

Last, but not least, binderies assemble and bind your finished multi-page publications and mailhouses insert, label, sort, tie, stack, and mail your finished projects. As in any assembly line, missed pages or missed pieces can mean the difference between a successful project or a war story. Your printer may offer these services, but if not ask him to recommend services he knows perform consistently well.

A final note—to choose the right players takes time. Once you have your different teams assembled, you don't need to start over for every project. It's important to keep checks and balances in place by getting quotes occasionally to ensure that your vendors' pricing is still competitive. When you work with the same team over time, you build quality working relationships and, in the final analysis, this is what yields quality work!

Key Terms

The following key terms are found in this chapter. See the glossary at the back of the book for detailed definitions.

ad agency (page 14)

blanket (page 17)

bleed (page 16)

coated paper (page 16)

collateral (page 20)

color separation (page 23)

continuous forms (page 16)

copywriter (page 14)

darkroom services (page 21)

die cutting (page 18)

embossing (page 18)

fiery (page 23)

finishers (page 20)

foil stamping (page 18)

free-lancer (page 14)

graphic artist/designer (page 14)

halftones (page 22)

letterpress (page 20)

linotronic film output (page 23)

markups (page 13)

mechanicals (page 15)

offset lithography (page 17)

offset printing (page 17)

page layout (page 22)

perforation (page 18)

plate (page 17)

PMS colors (page 17)

portfolio (page 14)

prepress services (page 16)

press proofs (page 21)

print media (page 14)

printing brokers (page 13)

process colors (page 17)

production coordinators (page 14)

renderings (page 15)

reprographic services (page 23)

scanning (page 21)

score (page 18)

screened images (page 22)

sheet-fed (page 18)

silk screen printing (page 19)

thumbnail (page 18)

trapping (page 15)

typography (page 16)

varnish (page 20)

vendors (page 20)

web (page 18)

Type & Design

> When a match has equal partners, then I fear not.
>
> *Aeschylus*

Whether you are typesetting or designing your printed piece yourself or you are relying on the work of team members, a beginning knowledge of type and design will help you direct your project more effectively.

When you are speaking in front of an audience, the intonations of your voice and your facial expressions help you to emphasize your salient points. On a piece of paper, your selected typefaces, design elements, and layouts are the vehicles to express your voice when you can't be there in person.

A romantic history

Around 1450, Johann Gutenberg revolutionized printing methods by inventing movable type. Letters were cast in reverse on individual pieces of metal—a mirror image of how the type would actually appear when produced. The typesetter or compositor would select each individual letter and place it face up in a composing stick, a box that would hold about a dozen lines of type.

This process seems arduous today, but compare it to the fact that prior to Gutenberg's time each copy of every book had to be laboriously handwritten! This comparison makes it clear to see why movable type resulted in a communication explosion around the world.

Much of the historical terminology of typesetting remains today even though most type is now produced using digital computer technology. Although these traditional definitions are still in existence, some of them have changed slightly in meaning in their present-day use.

Are you my type?

There are almost as many typefaces and typestyles as there are human personalities and styles of dressing. Typefaces are named type designs, such as Palatino, Garamond, Helvetica, Tekton, Goudy Old Style.

When typesetters refers to a style of type they are talking about type variations, such as roman (designated by the word "plain" or "regular" in some software menus), italic or oblique, bold italic, condensed, etc.

Type families contain all the variations and styles of a typeface with similar design characteristics. Type families consist of the basic roman, italic and bold variations. Some enlarged families also have additional styles such as condensed or expanded.

In traditional terminology, the word "font" meant one size and design of a given typestyle, including capital letters and lower case letters, numerals, fractions, punctuation symbols, accented characters, bullets, and other miscellaneous symbols.

To make this maze of jargon more complex, in present-day use typeface and font have become synonymous! The most important issue is to make sure you and your typesetter are speaking the same language. Tables 3-1 to 3-4 present these terms again with some representative examples.

TABLE 3-1: THE SAME SENTENCE TYPESET IN DIFFERENT TYPEFACES

Every human being has a unique personality.	Optima
Every human being has a unique personality.	Present
Every human being has a unique personality.	Palatino
Every human being has a unique personality.	Futura
Every human being has a unique personality.	Helvetica

TABLE 3-2: DIFFERENT TYPESTYLES OF THE SAME TYPEFACE

Each personality is multidimensional.	Helvetica Regular
Each personality is multidimensional.	**Helvetica Bold**
Each personality is multidimensional.	***Helvetica Bold Italic***
Each personality is multidimensional.	*Helvetica Italic*

TABLE 3-3: FONT CHARACTERS—HELVETICA ITALIC 10 POINT

a b c d e f g h i j k l m n o p q r s t u v w x y z
A B C D E F G H I J K L M N O P Q R S T U V W X Y Z
1 2 3 4 5 6 7 8 9 0 . , ; : ' ' & ! ? $

TABLE 3-4: MEMBERS OF THE TYPE FAMILY OF HELVETICA

We are individuals, yet family members.	Helvetica
We are individuals, yet family members.	**Helvetica Black**
We are individuals, yet family members.	Helvetica Compressed
We are individuals, yet family members.	Helvetica Condensed
We are individuals, yet family members.	**Helvetica Condensed Bold**

Getting to know you

As you get to know someone, that person's character, virtues, vices and habits become familiar to you. The special features that set this new person apart from others you have known become more and more clear. In a similar way, when you first start working with typefaces it may be difficult to distinguish them from each other. After a while, typefaces that at first looked the same when you put them down on a sheet of paper together, start taking on a character all their own.

Isolating a particular letter and comparing it across several different typefaces can help you to see these distinguishing features. Table 3-5 shows you a comparison of four different lowercase letters in different typefaces.

TABLE 3-5: LOWERCASE LETTERS IN DIFFERENT TYPEFACES

Caslon	Optima	Berkeley	Nadianne	Futura
a	a	a	a	a
e	e	e	e	e
f	f	f	f	f
g	g	g	g	g

Body types

All typefaces fall into one of two categories of body types: serif and sans serif. Serif typefaces have little feet at the ends of strokes of letters; sans serif (sans means "without" in French) typefaces do not. Many studies have shown that serif typefaces and shorter line lengths are easier for people to read over extended periods of time. Table 3-6 shows a selection of serif and sans serif typefaces.

TABLE 3-6: A SELECTION OF SERIF AND SANS SERIF TYPEFACES

Romeo & Juliet	sans serif
Cleopatra & Marc Antony	serif
Bogie & Bacall	serif
Katharine & Spencer	sans serif
Elizabeth & Richard	**serif**
Ozzie & Harriet	sans serif

A primer on points and picas or does size matter?

Historically, typographers have measured in picas and points. A pica consists of 12 points. There are *approximately* 6 picas or 72 points to 1 inch. Typical text type for the body copy of a book might be 9 to 14 points. Display type for headers might be 14 to 18 points or larger.

The point size of a particular typeface is measured from the top of an ascender to the bottom of a descender. In Table 3-7, the word "exciting" is typeset in 30 point Times Roman. Unfortunately, you can't rely totally on this system of measurement to pick the size of a typeface. Two different typefaces both set in 14 point may look very close in size or they may not. For example, the lovers' names in Table 3-6 are all typeset in 14 point!

The x-height, the height of the letter "x" in that typeface, changes your perception of the overall size. Section C of Table 3-7 shows the same word at the same point size in different typefaces. Notice how different they appear.

Digital typesetting is not limited to the traditional type sizes of the past. For example, if a typeface would look best at a size between 9 and 10 point some software programs allow you to create a 9.5 point size.

Reverse-out type is type that appears to be white on a background of black or color. The header at the top of this page contains reverse-out type. The background area is printed with ink and the letters are the areas that are <u>not</u> inked. When using reverse-out type it is important to use bold letters so some ink spreading from the background will not make your text illegible.

Leading (pronounced ledding) is the space inserted between lines of type. The term leading originally comes from the thin strips of metal inserted to increase the space between lines of type. For example, $^{10}/_{12}$ Garamond would designate 10 point type with 12 point leading, which actually translates into 2 extra points of space in between lines.

TABLE 3-7: A PRIMER ON POINTS AND PICAS

SECTION A: MEASURING POINT SIZE

SECTION B: A COLUMN WIDTH OF 24 PICAS OR 4 INCHES

24 picas wide

←——————————————————————————————————————→

What was it about him that had initially fascinated her? She didn't know how to put it into words, she only knew that when he entered the room it was as if a large and powerful thunderstorm had intruded on a crisp, sunny day. The air seemed electrified.

SECTION C: THE SAME WORD AT THE SAME POINT SIZE

relationship relationship **relationship** relationship

SECTION D: EXAMPLES OF REVERSE-OUT TYPE

**Making a bold statement was part of her style.
He was too old-fashioned to be with her.**

Table 3-8 shows the same typeface in the same point size with different leading. Notice how the spacing affects the readability of the paragraph.

TABLE 3-8: PARAGRAPHS SET WITH DIFFERENT TYPE SIZES & LEADING	
$^{11}/_{11}$ **Weiss** In a happy relationship, lovers have intimacy without crowding each other too much. This difficult balance will be different for every couple. It is a deciding factor in the longevity of the relationship.	$^{11}/_{12}$ **Weiss** In a happy relationship, lovers have intimacy without crowding each other too much. This difficult balance will be different for every couple. It is a deciding factor in the longevity of the relationship.
$^{11}/_{13}$ **Weiss** In a happy relationship, lovers have intimacy without crowding each other too much. This difficult balance will be different for every couple. It is a deciding factor in the longevity of the relationship.	$^{11}/_{14}$ **Weiss** In a happy relationship, lovers have intimacy without crowding each other too much. This difficult balance will be different for every couple. It is a deciding factor in the longevity of the relationship.
$^{11}/_{16}$ **Weiss** In a happy relationship, lovers have intimacy without crowding each other too much. This difficult balance will be different for every couple. It is a deciding factor in the longevity of the relationship.	$^{11}/_{18}$ **Weiss** In a happy relationship, lovers have intimacy without crowding each other too much. This difficult balance will be different for every couple. It is a deciding factor in the longevity of the relationship.

Are we getting closer or are we drifting apart?

Just as the space between lines affects the readability of type, so does the space between characters. Take a look at the examples below:

tight tracking → We seemed to be getting closer and closer.

regular tracking → There was a good balance between us.

expanded tracking → We were drifting apart.

Tracking adjusts space between character pairs in the range of text that you have selected. In the header at the top of this page, three different levels of tracking were used. Can you tell where the spacing changes in each case?

In display type, two letters may sometimes seem to have an unnatural amount of space between them. To tighten the space between two selected letters, you can adjust the kerning. Take a look at the following example of display type:

Darling

↑
notice the amount of space between the capital **D** and the lowercase **a**

Darling

↑
in this sample the space has been tightened by kerning

33

Aligning together

The format you choose for aligning your type is an integral part of your design layout. There are four basic ways to align type on the page: centered, ragged right, ragged left, or justified. Table 3-9 shows examples of these different ways to align type.

The text in this book has been typeset justified. Paragraphs in this text have been separated by a line of space. Another common way to separate paragraphs is to indent the first line.

TABLE 3-9: STYLES OF TYPE ALIGNMENT	
CENTERED "Now that's the way I like a conversation to open." She dug quietly at her ice cream. "No—don't tell me where or when or how you were in love with me. We'll save that for next time. You've taken away my appetite with your talk."	**FLUSH LEFT, RAGGED RIGHT** "Now that's the way I like a conversation to open." She dug quietly at her ice cream. "No— don't tell me where or when or how you were in love with me. We'll save that for next time. You've taken away my appetite with your talk."
FLUSH RIGHT, RAGGED LEFT "Now that's the way I like a conversation to open." She dug quietly at her ice cream. "No— don't tell me where or when or how you were in love with me. We'll save that for next time. You've taken away my appetite with your talk."	**JUSTIFIED (FLUSH LEFT & RIGHT)** **WITH PARAGRAPH INDENT** "Now that's the way I like a conversation to open." She dug quietly at her ice cream. "No— don't tell me where or when or how you were in love with me. We'll save that for next time. You've taken away my appetite with your talk."

paragraph excerpt from Ray Bradbury's *Dandelion Wine*, published by Bantam Books, New York

34

There are many inventive ways to set up column widths for your type projects. Column widths affect the overall look of your layout; they also control the number of characters you can fit on a page. Table 3-10 shows thumbnails (miniature pages) of the same type with different column formats.

TABLE 3-10: EXAMPLES WITH DIFFERENT NUMBERS OF COLUMNS

1-COLUMN FORMAT

2-COLUMN FORMAT

3-COLUMN FORMAT

2-COLUMN WITH PULL-QUOTE

Work will keep us together

It sometimes takes work to stay together. When you are typesetting, words, sentences, and paragraphs will sometimes fall out on the page in a disconnected way. As you become more experienced in working with type and layout, your techniques for solving typesetting problems will become more sophisticated.

A common problem that takes effort to correct is when a widow starts a column or an orphan ends a column. A widow is the last line of a paragraph that falls at the top of a column. An orphan is the first line of a paragraph that falls at the bottom of a column. Sometimes widows and orphans are just single words.

Tracking adjustments usually alleviate these typesetting problems, but these adjustments sometimes create other problems that also need to be fixed! Table 3-11 compares an example containing widows and orphans to a revised sample where these problems have been corrected.

If an outside vendor is writing or typesetting part of your project, it is valuable for you to take the time to learn standard copyediting and proofreading marks. These marks take practice to learn and use effectively, but you can potentially save thousands of dollars by taking the time to do so. The reason is that typesetting corrections, even with the powerful digital technology currently available, still take time. Clear, concise markings save the typesetter valuable time, which translates into saved dollars on your projects.

Find out from your typesetter how he or she wants items marked. Most typesetters prefer red pencil or ink so that corrections stand out on the typeset page.

Table 3-12 displays the most common copyediting and proofreading marks. Each marked example is accompanied by its revised version.

36

Table 3-11: Correcting Widows and Orphans

3-Column Sample When First Typeset

As she turned the pages slowly, she could tell this book had been a labor of love for him. The design, the words, the colors marked a style that was as connected to him as his own signature.

Ten years had passed since she had last talked to him. And yet, it was as if someone had spoken his name over and over

again on the pages. *widow*

For a minute she was back in his office again. Sitting there with their legs all tangled together, they sipped extra-bitter coffee, as they poked fun of the proposed production schedule for the following week. Some projects were obviously destined for file thirteen.

There were noises of *orphan*

paper shuffling outside the door. A discreet friend was trying to warn them of an impending interruption by one of the higher ups.

But the warning came too late, a split second and the big boss boomed into the room. Papers and coffee flew everywhere and when they stood up they realized

3-Column Sample Revised

As she turned the pages slowly, she could tell this book had been a labor of love for him. The design, the words, the colors marked a style that was as connected to him as his own signature.

Ten years had passed since she had last talked to him. And yet, it was as if some-one had spoken his

name over and over again on the pages.

For a minute she was back in his office again. Sitting there with their legs all tangled together, they sipped extra-bitter coffee, as they poked fun of the proposed production schedule for the following week. Some projects were obviously destined for file thirteen.

There were noises of paper shuffling outside the door. A discreet friend was trying to warn them of an impending interruption by one of the higher ups.

But the warning came too late, a split second and the big boss boomed into the room. Papers and coffee flew everywhere and when they

Notice that the tracking in the second paragraph has been expanded so that another line will spill over into column 2.

TABLE 3-12: COPYEDITING AND PROOFREADING SYMBOLS

symbol	marked line	revision
ℰ delete	She kissed him ~~twice~~ twice.	She kissed him twice.
⊙ period	Cupid was his co-pilot⊙	Cupid was his co-pilot.
∧ insert	*never* His love letter was ∧ sent.	His love letter was never sent.
# space	Love will keep#us#together.	Love will keep us together.
bf boldface	I will love you forever.	I will love you **forever.**
⌒ close up	His tone was dis ∧ heartening.	His tone was disheartening.
ital italic	She could feel his look.	She could *feel* his look.
(rom) roman	How dare he talk to her!	How dare he talk to her!
(cap) set in capital letters	Love is a four-letter word.	LOVE is a four-letter word.
(sm cap) set in small caps	Being in love meant he would never be free again.	Being in love meant he would NEVER be free again.
ℰ delete and close up	Marion ∧looked at him longinggly.	Marion looked at him longingly.
(stet) keep as it was before	She hated his ~~cruel~~ wit. *stet*	She hated his cruel wit.
∧ insert comma	By his actions∧he betrayed his love for her.	By his actions, he betrayed his love for her.

38

TABLE 3-12: COPYEDITING AND PROOFREADING SYMBOLS *continued*

symbol	marked line	revision
transpose	His poem was the prefect marriage porposal.	His poem was the perfect marriage proposal.
spell out	The tear-stained (ltr.) was all she had left of their affair.	The tear-stained letter was all she had left of their affair.
lowercase	He could Sense her need for SOLITUDE.	He could sense her need for solitude.
start new paragraph	Suddenly, all their anger had faded away. They were gazing at each other like two children with a special secret. What they had thought was the end of their intimacy had been just a temporary storm. The rest of the afternoon passed happily. They opened the windows of the cottage. A cool breeze made the curtains dance in the air.	Suddenly, all their anger had faded away. They were gazing at each other like two children with a special secret. What they had thought was the end of their intimacy had been just a temporary storm.　　The rest of the afternoon passed happily. They opened the windows of the cottage. A cool breeze made the curtains dance in the air.
align horizontal	His presence made her days roller coaster by.	His presence made her days roller coaster by.
align vertical	The slowness of time was no more, and she began to fear his leaving.	The slowness of time was no more, and she began to fear his leaving.

TABLE 3-12: COPYEDITING AND PROOFREADING SYMBOLS *continued*

symbol	marked line	revision
(run in) run in	Her abrupt departure had destroyed his self= confidence.	Her abrupt departure had destroyed his self-confidence.
= retain hyphen		
] [center horizontal	*Love is a balanced scale.*	*Love is a balanced scale.*
⊔ ⊓ center vertical	*Love is a balanced scale.*	*Love is a balanced scale.*
center all directions	*Love is a balanced scale.*	*Love is a balanced scale.*
⌐ flush right	Kevin saw her standing at the photocopier. He wondered if she had received his e-mail asking her to lunch.	Kevin saw her standing at the photocopier. He wondered if she had received his e-mail asking her to lunch.
⌐ flush left		
∨ apostrophe	The magic formulas danced in Peter's head. Was the symbol x3 or x3? He didn't have a clue. Around her, his power to reason had vanished; the fact that his beloved was his employer didn't factor into the equation.	The magic formulas danced in Peter's head. Was the symbol x^3 or x_3? He didn't have a clue. Around her, his power to reason had vanished; the fact that his beloved was his employer didn't factor into the equation.
∨ superscript		
∧ subscript		
∧ semicolon		

40

TABLE 3-12: COPYEDITING AND PROOFREADING SYMBOLS *continued*

symbol	marked line	revision
⊙ colon "⁄" quote marks	He had brought gifts to her⊙ flowers, candy, jewelry. But she said "Go away" and refused to talk with him.	He had brought gifts to her: flowers, candy, jewelry. But she said "Go away" and refused to talk with him.
⅋ ⅋ parentheses or brackets []	She hoped(and prayed)that he would return.	She hoped (and prayed) that he would return.
$\frac{\mid}{M}$ em dash (dash the size of the letter "m" in that typeface)	Love is—the answer. M	Love is–the answer.
wf wrong font	Thirty *years* had not cooled their passion.	Thirty years had not cooled their passion.
eq equalize space	Too ∨much time ∨ and space had ∨distanced their closeness.	Too much time and space had distanced their closeness.

Romancing the tone

Now that you have gained some knowledge about type and how to specify type, you need to go back and review your concept, your audience and what tone you want to convey before selecting type and preparing a layout.

41

Throughout the design process, it is important to keep asking yourself: Is the selection and spacing of type helpful, neutral, or detrimental to the message? Once you have specified the typefaces you want, the next step is to pick design elements to underscore your point by shouts or whispers.

By design

Art is a marriage of the conscious and the unconscious.

Jean Cocteau

Type and design go hand in hand to convey your message to your audience. There are an infinite number of ways to combine type with design elements to produce eye-appealing layouts. Photographs, illustrations, rules, borders, screen tints, and color are all elements that can be combined creatively with type to convey your message. You can even make display type the focal point of your design!

Table 3-13 displays different design treatments of the chapter opener of a romance novel. Notice how the "tone" of each treatment differs.

TABLE 3-13: ONE ROMANCE, FOUR WAYS

Broken Hearts

His deceptive deeds had done their damage.

SHE DIDN'T FEEL THE SAME WAY ABOUT HIM ANYMORE. Now that it was finally happening, she felt a shaky sense of serenity she hadn't experienced before. A feeling of liberation swept over her daily thoughts as she imagined her new life without him.

She was trying to take it slowly, step-by-step she kept telling herself. But, like a newborn colt, her legs crumpled under the weight of the adventure ahead.

broken Hearts

His deceptive deeds had done their damage.

She didn't feel the same way about him anymore. Now that it was finally happening, she felt a shaky sense of serenity she hadn't experienced before. A feeling of liberation swept over her daily thoughts as she imagined her new life without him.

She was trying to take it slowly, step-by-step she kept telling herself. But, like a newborn colt, her legs crumpled under the weight of the adventure ahead.

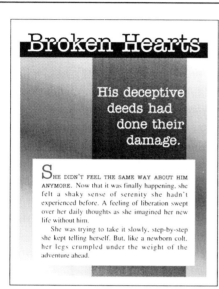

Broken Hearts

A feeling of liberation swept over her daily thoughts as she imagined her new life without him.

His deceptive deeds had done their damage. She didn't feel the same way about him anymore. Now that it was finally happening, she felt a shaky sense of serenity she hadn't experienced before. A feeling of liberation swept over her daily thoughts as she imagined her new life without him.

She was trying to take it slowly, step-by-step she kept telling herself. But, like a newborn colt, her legs crumpled under the weight of the adventure ahead.

His deceptive deeds had done their damage. She didn't feel the same way about him anymore. Now that it was finally happening, she felt a shaky sense of serenity she hadn't experienced before. A feeling of liberation swept over her daily thoughts as she imagined her new life without him. She was trying to take it slowly, step-by-step she kept telling herself. But, like a newborn colt, her legs crumpled under the weight of the adventure ahead.

BROKEN HEARTS

43

A tryst with technology

Computers are useless. They can only give you answers.

Pablo Picasso

Most typesetting work today is created digitally using personal computers. Popular page layout programs—such as QuarkXPress and Adobe PageMaker—offer graphic designers and typesetters the versatility to create flexible page layouts quickly. The layout of this book was prepared using QuarkXPress.

Two of the most popular programs for manipulating illustrations and photographs are Adobe Photoshop and Adobe Illustrator. If you want further information on how to begin setting up an efficient desktop publishing system for creating typesetting and graphics, take the time to review the resource list on the next page.

A frequent misconception is that all you have to do is buy one of these programs, hop on the computer, tap out a few keystrokes, drag the mouse around a few times, and within minutes you will have produced a masterpiece. Wouldn't it be wonderful if life was really this effortless? The truth is computer programs are tools for creating artwork. In a sense, these sophisticated programs are no different than paintbrushes, pens, palettes, or paint. You might be able to get the idea of how to use these tools quickly, but it will take time, practice, and experience to create another Mona Lisa.

The basic knowledge in this chapter is just the romance. Imagination, inspiration and a desire to captivate your readers will get you started, but it takes work, openness to new ideas, and research to make this work a life-long love affair.

Desktop Publishing Resources

TYPE/DESIGN

The Non-Designer's Design Book: Design and Typographic Principles for the Visual Novice, by Robin Williams, Peachpit Press: August 1994

Not the comedian we all know and love, but a comedienne in her own right, Robin Williams teaches the four concrete principles of design—proximity, alignment, repetition and contrast in this irreverent, introductory design book.

QUARKXPRESS

The QuarkXPress 4 Book: For Macintosh and Windows, by David Blatner, Peachpit Press: July 1998

This book is the highest rated, most comprehensive and best selling of the QuarkXPress books on the market. Blatner has achieved the impossible by writing an extensive technical Bible that is a joy to read.

ADOBE PHOTOSHOP

Photoshop 5 Bible, by Deke McClelland, IDG Books Worldwide: July 1998

This extensive guide to Photoshop 5 for Macintosh and Windows helps beginning, intermediate and advanced users learn essential techniques for the creation, editing and retouching of images.

ADOBE ILLUSTRATOR

Real World Illustrator 8, by Deke McClelland, Peachpit Press: November 1998

Adobe Illustrator is one of the most powerful software tools available for illustrating and designing print and web publications. This definitive guide is entertaining, up-to-date and comprehensive.

45

Key Terms

The following key terms are found in this chapter. See the glossary at the back of the book for detailed definitions.

ascender (page 31)

baseline (page 31)

body copy (page 30)

bullets (page 26)

centered (page 34)

condensed type (page 26)

copyediting (page 36)

descender (page 31)

desktop publishing (page 44)

expanded type (page 26)

flush left (page 34)

flush right (page 34)

font (page 26)

italic/oblique type (page 26)

justified (page 34)

kerning (page 33)

leading (page 30)

orphan (page 36)

pica (page 30)

point (page 30)

point size (page 30)

ragged left (page 34)

ragged right (page 34)

reverse-out type (page 30)

roman type (page 26)

rules (page 42)

sans serif (page 29)

screen tints (page 42)

serif (page 29)

tracking (page 33)

type families (page 26)

typeface (page 26)

typesetter/compositor (page 25)

typesetting (page 25)

typestyle (page 26)

widow (page 36)

x-height (page 30)

VISUAL MAGIC

The eyes are not
responsible when
the mind does
the seeing.

Publilius Syrus

Imagine that you are the inventor of an exciting new product. Your new product is a time machine and you hope that by introducing it to the correct markets you will become very, very rich and possibly quite powerful. You decide to put together a quick bulletin on a single sheet of paper to hand out as a preliminary announcement about your product. Since you are, unfortunately, still a struggling inventor, you don't have the budget to hire a professional photographer so you use your own camera and some black and white film to take a photo of your time machine. When you take a photo in this way you are using creative photography.

Photography is a relatively new art form. If you hopped into your time machine and travelled back to 1820, you would see that there were no photos in advertisements, no photo identification tags, and no photographs of famous people. Photo images are so pervasive in our society today that it is difficult to imagine a world without photography.

The process of photography was invented in 1839 by the scenic painter Daguerre. The first camera captured a specific moment in the life of a person, sequence of an event or season of a place. It's no wonder that the

first time primitive people saw a camera they considered it evil magic. The camera could steal a person's soul.

Illusions in Ink

Life is not about significant details, illuminating in a flash, fixed forever. Photographs are.

Susan Sontag

Commercial photographers, art studios, creative art departments and hobbyists take photographs. These photographs provide the original images for printed pieces.

If you use a magnifier to look at an original black and white photo, you will see it is made up of continuous, flowing gradations of black to many levels of gray to white. This effect is called continuous tone. Illustrations rendered using shades of gray are also considered to be continuous tone.

There is no way possible to show you an example of a continuous tone image unless we place an original photograph or an original tonal illustration into every copy of this book. Not a very practical idea! And so, a second type of photography was necessary—a type of photography that would make it possible to reproduce an original photo into a form that was printable many times over. Thus, graphic arts photography, an integral part of the printing process, was born.

In order for you to reproduce a black and white photo of your time machine in your announcement flyer, it must first be converted into a halftone. Remember all the gradations of black to gray to white that exist in your original? A halftone makes it possible for an offset press to depict your photo using just one color of ink—black. The halftone is really an optical illusion. It tricks your eyes into thinking you are seeing grays of a continuous tone when you are not seeing that at all. Use a magnifier to look at a black and white photo in your local newspaper to see this in

detail. The newspaper halftone is made up of a large number of dots of different sizes with equal spacing between their centers. It is printed using black ink. The halftone areas with smaller dots allow the paper to show through and create highlights; the areas with larger dots create shadows by showing less paper. **All printed materials depict photos by using halftones.** The resolution of the halftones varies depending on the press and paper used. The halftones reproduced in this book are higher resolution than newspaper halftones, but probably lower resolution than those in a glossy coffee-table book.

making magic happen

There are two ways to create a halftone. One method begins by using a scanner to scan the continuous tone image into a computer. Software used for modifying photos can be used to change the digitized image and, in general, the final halftone is printed out either as a positive paper image via a laserprinter or as a piece of negative film via an imagesetter.

The second method is the more traditional method of using contact screens. Contact screens are flexible pieces of film with precision patterns of dots. An original photo is placed on the copyboard of a graphics arts camera. Light passes through the contact screen breaking the original photo image into a series of dots and contacting a second piece of film into a final halftone negative.

Unfortunately, no special magic can transform an amateurish photo into a high-quality halftone. **Before you can produce a quality halftone, you must begin with a quality photograph.** As it is, some loss of tone is inevitable in the translation of a continuous tone original to a reproducible halftone. A quality black and white photo has sharp focus, good contrast with strong areas of black, clean areas of white, and a full tonal range of grays. It has fine detail, imagery that captures the viewer's eye and no visible scratches or blemishes.

Are you planning to use an enlarged version of your photo in your finished printed piece? If you are, it's a good idea to get a print at that size to make sure there are no flaws that distract your viewer from the subject. Also, make sure that the enlarged photo doesn't get too fuzzy or grainy for the effect you want to achieve in your final publication.

the case of the disappearing red

If you begin with a quality black and white original, your resulting halftone should meet your quality standards. But what happens if you begin with a color photo? You can convert a color photograph into a useable black and white halftone, but it will not be as high quality as a photo that was originally black and white. One reason is that graphic arts film translates red to black, thereby losing detail in areas that were originally red.

a scaling trick

If you begin with a 5 by 7 inch photo print and you want it to appear close to 3 by 4 inches in your finished brochure, can you get it that size? Original photos need to be proportional to the finished size you want the halftone to appear. Table 4-1 shows you a quick geometric trick for finding a proportional size for your photo.

If you are sizing your photo using a computer, you draw a diagonal line from opposite corners of your scanned image. Then grab the handle of your picture box and drag it along this diagonal to determine proportional dimensions for a reduced or enlarged version of your photo.

If you are working with an original, draw the dimensions of the photo on a piece of paper and then continue the process on paper so you can scribble out some possible dimensions without destroying your original print. In fact, it is important not to write on top of or on the back of your photo print. Quality prints can be easily damaged. If you need to identify your original write lightly in pencil or make a copy and reference it instead.

TABLE 4-1: A SCALING TRICK

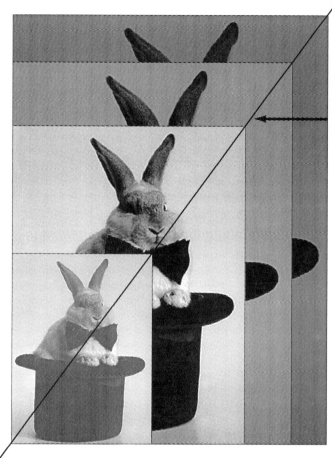

Drag the corner of your original along its diagonal to find unlimited proportional sizing possibilities.

This method gives you sizing options, but you will have to resize your photo scan to fit the final size you choose.

SIZES IN INCHES (APPROXIMATE)

reduction 1	original photo	enlargement 1	enlargement 2
1.5 wide	2.5 wide	3 wide	3.375 wide
2 tall	3.34 tall	4 tall	4.5 tall

If you want your finished halftone to fit in a different shape than the original, you will need to identify parts of the photo that can be cut or cropped out. Once you have changed the original to the shape you want, you can follow the same process to reduce or enlarge it.

The hand is quicker than the lpi

Different types of paper and production processes require different types of halftones. The terms **screen frequency, line screen** and **lines per inch,** abbreviated as **lpi,** are all synonymous. The lpi is a determining factor of how well a halftone will reproduce on a particular type of paper.

If you use a magnifier and compare a black and white halftone in a newspaper to a black and white halftone in a glossy magazine you will immediately see the difference in the screen frequency or lines per inch. In general, a halftone with a coarser line screen or less lines per inch will work best on newsprint or uncoated papers. On these surfaces ink tends to spread and details can get muddy as the dots of a halftone spread out toward each other. On uncoated papers, a coarser screen holds less ink making it possible for more details to remain open and crisp. Halftones with coarser screens also work best for photocopying since toner spreads differently than inks and photocopy paper is uncoated.

Coated papers, such as those used in many magazines and coffee-table books, tend to hold ink on their surfaces. Ink looks more vibrant on these papers and halftones can be reproduced with much finer screens or more lpi.

Table 4-2 gives you some guidelines on which line screen to select for the type of paper, process, and printing plates specified for your project. These guidelines provide you with some general ideas, but it is always important to discuss your expectations with your production team. They can advise you on the best options for a particular situation. Table 4-3 shows the same halftone at various lpi. Keep in mind that the inside of this book has been printed on an uncoated paper.

TABLE 4-2: SELECTING SCREEN FREQUENCY		
You should select	**Paper used**	**Process used**
60-85 lpi	newsprint, photocopy stock, or other lightweight uncoated paper	photocopying offset printing— quick printing with direct image plates
85-100 lpi	lightweight uncoated papers, such as 20 lb. bond or 60 lb. color stock	quality photocopying quick printing with direct image plates
100-120 lpi	heavier uncoated stocks, such as 70 lb. text stock, including recycled papers— also, uncoated cover stocks	quick printing or commercial printing with either direct-image or metal plates
120-133 lpi	in addition to heavier uncoated papers, also suitable for matte and gloss coated papers	commercial printing with either direct image or metal plates
133-150 lpi*	matte and gloss coated text and cover stocks, high gloss (magazine quality) text and cover	commercial printing metal plates
Over 150 lpi is achievable on specialty presses.		

TABLE 4-3: THE SAME HALFTONE REPRODUCED AT DIFFERENT LPI

90 lines per inch

120 lines per inch

133 lines per inch

150 lines per inch

dpi and lpi

When you use a laserprinter or an imagesetter, the final output is described in **dots per inch** or **dpi.** Most laserprinters produce output of at least 300 dpi, but many offices now have 600 and even 1200 dpi printers.

In a square inch of a finished printed image, a 300 dpi laser printer prints 300 x 300 or 90,000 dots! A 600 dpi laserprinter prints 600 x 600 or 360,000 dots in a square inch so the resolution of its output is four times the quality of a 300 dpi printer.

The higher the dpi, the higher the resolution of the output for all type and images. In other words, the more dots printed on the page both alone and in composite groupings of dots, the crisper and more detailed the final output will be.

Lpi, on the other hand, refers only to the lines per inch appropriate for halftone images (refer to Tables 4-2 and 4-3 for a refresher). The number of lines per inch determines how dots are positioned in a grid pattern to create a halftone image. The higher the frequency of the lines per inch, the higher the resolution of the halftone.

In a 1 inch by 1 inch 90 lpi halftone, printed on a 600 dpi printer, the image will be composed of 360,000 dots alone and in groupings arranged in a grid pattern of 90 lines per inch.

90 lpi **image is made up of 360,000 dots alone and in groupings**

Dpi and lpi are closely related. Experimentation with your computer and different output devices will help you determine the settings that work best for your particular halftone. **A successful halftone is a balance of high resolution without sacrificing the varying dot patterns which produce what your eye perceives as "levels of gray."**

Your eyes can actually see approximately 256 different levels or gradations of gray. The more "levels of gray" a halftone can trick your eye into seeing, the more successfully it has reproduced the look of a continuous tone photo.

The following formula will help you in making decisions about dpi and lpi settings:

$$\left(\frac{\text{dots per inch}}{\text{lines per inch}}\right)^2 + 1 = \text{number of levels of gray perceived}$$

Which of these combinations do you think would achieve the maximum number of "levels of gray"?

300 dpi printer output 60 lpi halftone	600 dpi printer output 70 lpi halftone	1200 dpi printer output 110 lpi halftone
$\left(\frac{300}{60}\right)^2 + 1$	$\left(\frac{600}{70}\right)^2 + 1$	$\left(\frac{1200}{110}\right)^2 + 1$
$(5)^2 + 1$	$(8.57)^2 + 1$	$(10.9)^2 + 1$
$25 + 1 = 26$	$73 + 1 = 74$	$119 + 1 = 120$
With this combination 26 levels of gray would be perceived	**With this combination 74 levels of gray would be perceived**	**With this combination 120 levels of gray would be perceived**

scanning slights of hand

There is a difference between what dpi signifies when you are outputting an image to a laserprinter versus what dpi signifies when you are scanning an image. Remember that on a laserprint a square inch of a 300 dpi image contains 300 x 300 or 90,000 dots. These dots are produced alone and in groupings but they are always strictly black. On the other hand, a scanner would record these 90,000 dots as gradients from black to levels of gray.

WAR STORY: Jason tells us—when I first started using a scanner, I scanned some photos from a local newspaper to use with a press release for a new company product. I didn't realize that since I was scanning an image that had already been halftoned before I was essentially placing a halftone over a halftone causing a strange moiré (moa-wray) pattern in the output image.

#12

BATTLE PLAN: Remember that scanning works best if you are using original line art, an original tonal illustration or original photos. If you decide to scan a preprinted halftone you need to find out if the original is copyrighted first. If so, you will need to obtain permission to reproduce it from the copyright holder. The process of obtaining permission takes time and there are usually fees involved. If you obtain permission and you want to scan a preprinted image, try to scan it at an angle that is 30-45 degrees different from the original angle of the halftone screen. Scanning the preprinted image at a coarser screen or lower resolution sometimes helps in preventing moiré patterns as well. Finally, scanning a preprinted color halftone usually works better than scanning a black and white halftone because color halftones have a more complex dot pattern that interferes less with scanning patterns.

A laserprint that is 1200 dpi is higher resolution than a 600 dpi laserprint. Therefore, type and images output at 1200 dpi are sharper than those output at 600 dpi. But the-more-dpi-the-better mentality does not work for scanning. For scans, more dpi does not necessarily mean better scans. If fact, high dpi scans take longer to scan, eat up huge amounts of computer memory, are slow to process and take a long time to output.

A rule of thumb is to scan your image at a dpi that is twice the lpi you want in your final output. Table 4-4 makes the following formula for scanning photos easier to understand.

$$\begin{array}{ccccccc} \text{final output} & & & & \text{\% of original} & & \text{scan original at} \\ \text{in lines per inch (lpi)} & \times & 2 & \times & \text{size for final} & = & \text{this number of} \\ & & & & & & \text{dots per inch} \\ & & & & \textit{Don't forget to change} & & \text{(dpi)} \\ & & & & \textit{percent to a decimal.} & & \end{array}$$

Final Output	Image Type/Size	DPI Setting
TABLE 4-4: CHOOSING THE CORRECT DPI SETTING FOR SCANNING		
Final Output	**Image Type/Size**	**DPI Setting**
Line art image at 600 dpi *remember that lpi applies only to halftones*	Original Line art at 100% of size	Scan at 600 dpi *notice that for line art the image is scanned at the same dpi as the desired output*
Halftone at 100 lpi	Original photo at 100% of size	Scan at 200 dpi *notice that for a photo the image is scanned at twice the lpi of the desired output*
Halftone at 150 lpi	Original photo at 75% of size	Scan at 225 dpi *using the formula, you get 150 x 2 x .75 = 225*
If you wanted a 133 lpi halftone that was 150% of the original size, what dpi would you use?		

Another factor to consider in the output of line art and halftones is whether you want to output to a positive or a negative format. The format of the output is controlled by the quality of the printing you expect for your result. If you are getting your material duplicated or quick printed you may want to use halftones that have been output as positives.

A laserprint of a halftone which was created by scanning an original photo is an example of a positive. A second example of a halftone positive is created using a graphics arts camera. This type of positive is called a PMT after the photomechanical transfer process used to create it.

A laserprint that has halftones and type positioned just as you want them in the final printed piece can either be duplicated from the original or shot as a direct image or silvermaster plate for quick printing. You can also affix PMTs to a page with type to create a master with images and type for duplicating or quick printing.

Quality commercial printing requires that halftones and type be output as negatives through either a traditional darkroom process or through linotronic (imagesetter) negatives. Metal plates are created from these negatives. You may want to review Table 4-2 on page 53 for a refresher on which lpi to select for the different printing methods available.

Duotones and Mock Duotones

Half the work that is done in the world
is to make things appear what they are not.

E.R. Beadle

Even a high-quality halftone can't fully display the complete tonal range of a quality black and white photograph. The contrast of the finished halftone must favor either shadow tones or highlight tones; it can't depict both fully. Using a duotone is a partial solution to this dilemma. Duotones are halftones created from two negatives. Each negative is printed in a different color and with a different screen angle and then both

are registered together to create one finished image. A typical duotone might have one negative printed in black with a high contrast exposure and its second negative printed in color with a middle tone exposure. Both negatives registered together create a full tonal range that creates a visually appealing effect. For an optimal duotone, begin with a black and white photo.

Duotones are more expensive than standard halftones because they require tight registration of two negatives, but they are less expensive than full process color. If you don't have the budget for a duotone, you might want to use a fake duotone. A fake duotone is a halftone over a flat screen of color.

TABLE 4-5: A DUOTONE AND ITS IMPOSTER

The Real Duotone

created with
two halftones, superimposed
at different screen angles

The Imposter

a halftone is
overprinted on a 30%
screen tint of color

The Alchemy of Color

Take your favorite magazine and with a powerful magnifier look at a full color photograph. You will see a magical rosette pattern of overlapping dots. The overlapping dots are made up of four ink colors—cyan, magenta, yellow, and black. These four ink colors are called the process colors. The process of creating the illusion of full color from these four inks is called process color or abbreviated as CMYK for cyan, magenta, yellow and black.

If you started with a full color photo of a magician pulling a scarf out of hat, your photo would have to be scanned using a high-quality color scanner to split the image into four negatives. The four negatives would each have different screen angles. One negative would be printed in cyan ink at 105° screen angle, one in magenta at 75° screen angle, one in yellow at 90° screen angle and one in black at 45° screen angle. They would be registered together very tightly on press. The finished image of overlapping dots tricks your eye into seeing all the colors of the rainbow.

Technically speaking, these negatives, called color separations, are halftones. Printing these four halftones is much more complex than the printing of standard halftones or duotones. The registration must be close to perfect otherwise the sharpness and color quality of the image will be lost. Table 4-6 shows the stages of the four-color process.

Another factor that is much more critical in process color than in other simpler types of printing is ink density. If one color is more dense than the others on press, the resulting photo may be cast too closely with that particular color and will be out of color balance. To avoid this problem printers use a special piece of equipment called a densitometer.

A densitometer measures the ink density of each color. Once the correct color balance has been established, the densitometer readings provide a basis of comparison throughout a print run.

TABLE 4-6: COLOR SEPARATIONS AND PROCESS COLOR PRINTING

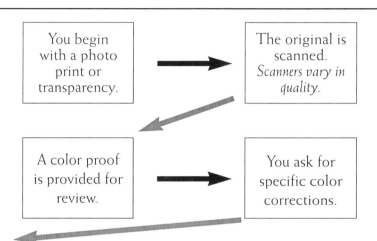

You begin with a photo print or transparency.

→

The original is scanned. *Scanners vary in quality.*

A color proof is provided for review.

→

You ask for specific color corrections.

You sign off on color corrections and four negatives are output. The negatives are used to create plates for each of the process colors. The colors are registered on press to create the final image.

Cyan Impression

Magenta Impression

Yellow Impression

Black Impression

The final process color (four color) image is created from all four impressions registered together.

The order in which the ink colors are printed varies depending on the type of press used.

At the color proof or press check stages, you should express any concerns you have about brightness, crispness or color quality of the final color image. Adjusting color is a very subjective process. What looks pleasing to one person looks out of color balance to another. Color separation houses can make a great many adjustments to improve the final color quality, fine detail, and density of color before negatives are output. Your press operator can also make press adjustments to improve image quality.

Despite careful attention to detail and numerous color adjustments, even the best premium printing cannot fully duplicate the color range of a continuous tone color photograph. After all, only four ink colors are used to give the illusion of the millions of colors the human eye can perceive.

Some prepress services and premium printing houses are experimenting with a new method to print full color called high-fidelity color. Instead of separating color photos into just four negatives they are separated into five or more negatives. This method allows for an additional yellow, or maybe two additional red impressions to be registered along with the standard process colors. The resulting image is closer to the full color range of color photography, but it is expensive and only the best equipment and operators can achieve the necessary registration.

The paper you select makes a great deal of difference in the look of your final color project. Color looks most vivid on bright white gloss coated stocks, but full color can be successfully printed on matte finish, uncoated and even color stocks, depending on the final effect you want to achieve.

In the past, process color printing was not a viable option for companies with modest budgets. Thanks to new technology, especially at the prepress stages, the process of four color printing has become more accessible as well as more affordable. Graphics magicians everywhere are using process color to create colorful worlds of words and images.

Key Terms

The following key terms are found in this chapter. See the glossary at the back of the book for detailed definitions.

contact screens (page 49)

continuous tone (page 48)

densitometer (page 61)

dots per inch/dpi (page 55)

duotone (page 59)

graphic arts photography (page 48)

halftone (page 48)

high-fidelity color (page 63)

imagesetter (page 49)

line screen (page 52)

lines per inch/lpi (page 52)

mock duotone (page 59)

moiré pattern (page 57)

PMT (page 59)

process colors (page 61)

registration (page 60)

resolution (page 48)

screen angle (page 59)

screen frequency (page 52)

64

Dressing Paper

Whatever you do,
kid, serve it up
with some dressing.

Spencer Tracy

You have a clear concept, a well-chosen team of in-house staff and vendors and your designed document is beautifully illustrated with art and photos. You have incorporated the latest state-of-the-art technology to prepare your prepress materials. What could possibly go wrong now? Unfortunately, an unwise choice of paper and color can result in disaster in the final stages of your project.

Selecting from the paper and color palette

Your designer, printer and local paper store are excellent resources as you wade through the many papers currently available for purchase. Many paper stores sell direct to the general public as well as to printers. All these sources have paper and color samples you can refer to as you make choices for your project.

Paper mills supply paper stores, printers and other distributors with paper sample books that show printed designs and photos with different color

inks as well as different printing and finishing techniques. Many of these samples list the techniques used to create the printed art displayed.

Paper samples can provide inspiration for design ideas in addition to helping you decide whether your current ideas will translate well to a particular paper's color and texture.

Working with sample books can be somewhat deceptive, however. Not all samples are readily available and not all paper vendors carry all lines of paper. Each paper company carries a specific line of papers from their selected paper mills. Most printers only work with two or three different paper companies. Your selected printer will show you the lines of paper he or she feels will suit your design and budget requirements.

It's always a good idea to have one or two back-up paper selections as well as your top choice when you make a final decision on paper. You may find that your top choice is not in stock when you place your order. Back orders on paper typically occur because the mill is manufacturing more stock, which translates into a delay of a few days to as much as 2-3 weeks.

Just like styles of clothing, paper colors and styles go in and out of vogue. A paper sample that you have had for a few months may no longer reflect the colors or textures that manufacturer is currently offering.

Pick a paper and paint it!

Art is the expression of an enormous preference.

Wyndham Lewis

When picking a Pantone Matching System (PMS) color for your project, it's helpful to place the swatch of color directly down on the paper you're hoping to use. An ink swatch book is useful for this purpose. The Pantone Matching System swatch book is divided into two general categories. All ink colors are shown on uncoated and coated papers.

TABLE 5-1: TOOLS FOR COLOR SELECTION

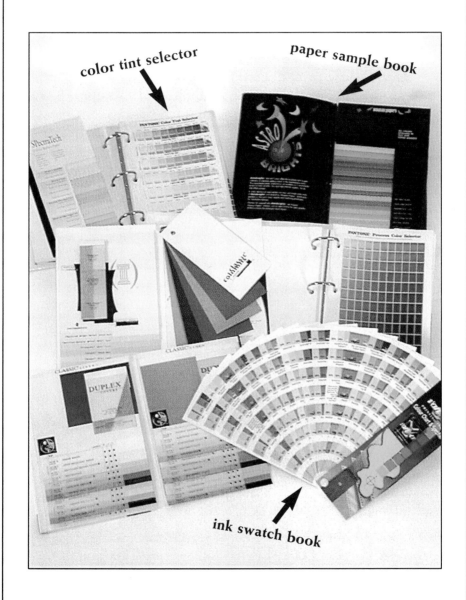

color tint selector

paper sample book

ink swatch book

Inks soak into the surface of uncoated papers, such as letterhead stock. In the PMS book, the inks shown on uncoated stock are designated with the letter "U." In other words, the sample for PMS 541 U shows the ink color 541 on an uncoated stock.

Slick magazine stock is an example of a coated paper. Colors look much more vibrant on these papers because the coating prevents the ink from soaking into the paper as much as on uncoated stock. Inks shown on coated paper samples in the swatch book are designated with the letter "C." The sample for PMS 541 C shows the ink color 541 on a coated stock.

Another very useful tool for making color decisions, is the color tint selector. This book shows how PMS colors will reproduce at different screen values. It also shows how black type will overprint on the selected screen of color, how reverse-out type will look on a selected screen of color, and how a representative halftone would look if you printed it in just that color. Like the PMS swatch book, the color tint selector is also divided into two sections—uncoated and coated papers.

You will need to use the PMS swatch book in tandem with the color tint selection to see the full range of a particular ink color. The swatch book shows the color printed at 100% strength with no screen tint. The color tint selector shows the color from a 10% screen tint to a 90% screen tint.

Table 5-1 shows some of the most useful tools for color and paper selection and Table 5-2 shows the information depicted for a particular PMS color in the color tint selector.

Keep in mind that ink samples only give a general idea how colors will look on white papers, both uncoated and coated. Offset inks are somewhat transparent, so the color, texture, fiber, and absorbency of the paper radically changes the way ink colors print. Ink colors are also affected by the balance of ink and water in the press as well as the number of sheets that are printed. Even environmental factors, such as the level of humidity in the air, can have an effect on the final ink color!

TABLE 5-2: TINTS OF PMS 186 U IN THE COLOR TINT SELECTOR

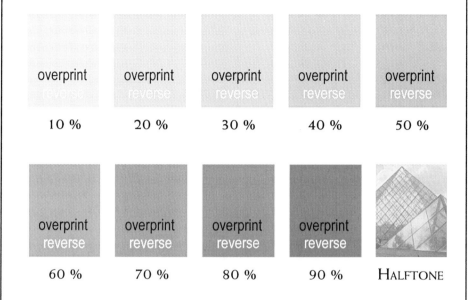

overprint reverse	overprint reverse	overprint reverse	overprint reverse	overprint reverse
10 %	20 %	30 %	40 %	50 %
overprint reverse	overprint reverse	overprint reverse	overprint reverse	
60 %	70 %	80 %	90 %	HALFTONE

Notice that reverse-out type does not work well on a screen tint that is too light. Also, overprinting does not work well when the background is too dark.

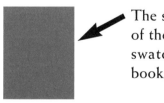

The swatch at the left shows 100% strength of the color PMS 186 U. This full-strength swatch can be found in the PMS swatch book, but not in the color tint selector.

100% OF
COLOR

This page is printed with just two colors, black and PMS 186 U.

WAR STORY: Susan tells us—I selected a bright orange **#13** stock for the cover of a children's workbook. I wanted a blue ink, PMS 300 U, for the cover but my printer was concerned about how the ink would be modified by the stock's color. When the job went to press, my printer called. The ink I had selected looked a sickly green on the orange paper, just as he had thought. It took some work to select a dark purple ink that worked on the orange paper. I was lucky that my printer worked with me on this. He charged me for some of his down time while we worked out the problem, but this was a lot less than I would have paid if I had had to reprint the entire project after it was printed and bound!

BATTLE PLAN: Ask for samples with the approximate color and paper you plan to use. If your designer or printer cannot supply this, (there are an infinite variety of paper and color combinations) consider obtaining a press proof if your budget allows. Your designer and press operator can usually give you good advice on what color/stock combinations look best. If they express concern, it's wise to listen.

Characteristics of paper

We live in a rainbow of chaos.

Paul Cézanne

All the available selections of paper and color may feel overwhelming to you, but generally you should consider the function of your printed pieces before you make your selections.

As you touch, explore and experiment with paper samples you will notice varying weights, different surface textures and colors. Is the paper lightweight and flexible or is it stiff or similar to board? Is its color neutral

or vibrant? Does it have a bumpy or specifically textured surface or is it smooth? Does the paper feel slick to the touch, like magazine stock? Is it see-through? Is it made from recycled wood pulp and does it show recycled flecks in it? Is it bright and reflective or is it dull? Does one paper feel bulkier than another if you use the same number of sheets of each type of paper and then compare the stacks?

TABLE 5-3: MAJOR CHARACTERISTICS OF PAPER

- weight
- color
- texture
- opacity (see-through-ness)
- uncoated versus coated

- recycled
- flexibility and grain
- dull finish to glossy finish
- brightness
- bulk

Picking papers perfectly

Most papers fall into four common categories: bond, book, text, and cover. Printers use the words "paper" and "stock" interchangeably.

BOND PAPER—There are many types of bond paper, but two of the most common are smooth xerographic bond for duplicating and writing bond. Xerographic bond is a lightweight 20 or 24 lb. stock used for duplicating so it is designed to take toner well instead of offset printing inks. Writing bond also comes in 20 and 24 lb. but it has a surface designed for printing inks as well as for handheld writing implements, such as fountain or ball point pens.

Writing papers frequently have a watermark, a name or graphic symbol that is manufactured into the surface of the paper. When you hold the

paper up to the light, you can see the watermark. If your letterhead has a watermark and it is preprinted with your logo and address, the printer loads the paper into the press so that the watermark will be right reading after the sheet is printed. Watermarks that are not right reading on printed letterhead are a sure sign of an inexperienced press operator! If you are laserprinting watermarked paper that has not been preprinted, make sure you load it into your laserprinter so that the watermark will read correctly when you are finished.

BOOK PAPER (UNCOATED)—Book papers come in uncoated and coated. Uncoated book papers, sometimes called offset papers, are most commonly used to print the interior text of catalogs, books, pamphlets, reports and other multi-page documents. For example, the interior of this book is printed on 60 lb. book stock. Book stock is also used for quick low-budget flyers.

Offset papers vary in brightness and quality. Some offset papers are more see-through than others. Less see-through uncoated book is sometimes called opaque paper. There are a wide variety of bulks, colors, and surfaces available in book stock.

Two different offset papers might be quite different in terms of bulk. If you choose a bulkier paper, 200 pages of material will look like more pages than it actually is…very useful for a doctoral thesis!

BOOK PAPER (COATED)—Coated book paper is book stock that has been coated with clay. Coated book is available primarily in white and different shades of white. A very important fact about coated paper is that ink does not absorb into coated book as much as it does with uncoated book, because the clay prevents ink absorption. These papers are perfect for high-end photo reproduction and process color printing where ink vibrancy and 133-150 lpi photos are the desired result. Use these papers for brochures, annual reports, magazines, book covers or any publication where photos and art must be at their best. Printing on coated papers takes a higher level of skill and generally costs more than printing on uncoated papers.

TEXT—Text papers are a designer's dream. They are available in a wide variety of colors, textures and special surfaces and make a designer statement even in areas of the paper that are unprinted. Recycled text papers are manufactured with different levels of pre-consumer and/or post-consumer waste paper. Many recycled papers have colorful fibers or dots of varying sizes, called ecospots, manufactured into the surface of the paper. These papers are used for letterhead and envelopes, as well as for flyers, brochures, self-mailers and booklets.

COVER—Cover stock is available in uncoated, coated one side (C1S) and coated both sides (C2S). Uncoated cover stock is thick and is used for business cards, book and booklet covers, greeting cards and invitations. Most cover papers are suitable for embossing, foiling, die-cutting, scoring and perforating as well as printing.

Designer text and cover papers come in matching colors, textures and surfaces so that you can plan coordinating pieces. For example, you might select a text paper for letterhead and envelopes with its matching cover stock for business cards. If you create an invitation, you might select cover paper for the foldover invitation with its matching text paper for envelopes and an insert. A presentation folder would be created from cover stock, but its interior flysheets might be printed on its matching text paper.

Coated one side or C1S cover is especially appropriate for book covers where you want the outside to be glossy but the inside to be uncoated for binding. This type of stock is also especially useful for postcards where the coated side is printed with a high resolution image or photo and the uncoated side is suitable for imprinting an address at a mailhouse.

Cover that is coated on both sides, C2S, is used for brochures and high-end pieces where you want graphics and photos to look their best throughout.

In addition to the four major categories of bond, book, text and cover there are many different types of specialty papers, such as NCR carbonless, label paper and lightweight index for postcards.

Weighty wise words

The way you buy and dress your paper will make a difference in whether your finished project looks like silk instead of polyester. In order to make wise paper purchases, you need a basic understanding of the weights of paper, because this is how printing vendors purchase paper.

Paper is manufactured and identified by its basis weight. In the United States, the basis weight is the weight in pounds of a ream, 500 sheets, in the basic size for that grade of paper. The "#" symbol is equivalent to "lb."

Table 5-4 is a summary of some of the common basis weights for different grades of paper. Some important equivalencies between different grades of paper with different basic sizes are not obvious. For example, 20# bond is equivalent to 50# book. To make matters more confusing, two different grades of paper with the same weights and different basic sizes are not equivalent! See Appendix A at the back of the book as a reference for equivalent weights of different grades.

WAR STORY: Angela tells us—I specified 80 lb. on my #14 fax instruction sheet to the printer for a brochure I was putting together. When I came to pick up the brochures, I was alarmed to see that they didn't feel as heavy as the business card weight paper I was hoping for. Because I hadn't specified otherwise, the printer had assumed the job was supposed to be printed on text paper so he printed the brochures on 80 lb. text instead of the stiffer 80 lb. cover.

BATTLE PLAN: Always specify bond, book/text or cover for the designated weights on your instructions to the printer. A sheet of 80 lb. text and a sheet of 80 lb. cover are not equivalent in thickness. In fact, a sheet of 80 lb. cover is approximately twice as thick as a sheet of 80 lb. text.

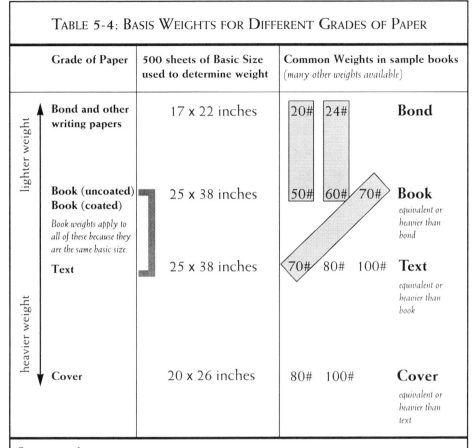

	Grade of Paper	500 sheets of Basic Size used to determine weight	Common Weights in sample books *(many other weights available)*	
lighter weight ↑	**Bond and other writing papers**	17 x 22 inches	20# 24#	**Bond**
	Book (uncoated) Book (coated) *Book weights apply to all of these because they are the same basic size.*	25 x 38 inches	50# 60# 70#	**Book** *equivalent or heavier than bond*
	Text	25 x 38 inches	70# 80# 100#	**Text** *equivalent or heavier than book*
heavier weight ↓	**Cover**	20 x 26 inches	80# 100#	**Cover** *equivalent or heavier than text*

TABLE 5-4: BASIS WEIGHTS FOR DIFFERENT GRADES OF PAPER

Some examples:

20# bond means that 500 sheets of 17 x 22 weighs 20 lbs.

24# bond means that 500 sheets of 17 x 22 weighs 24 lbs. and is therefore heavier than 20# bond.

70# book is equivalent to 70# text because they have the same basic size. In fact, all book and text weights are equivalent because they are based on the same basic size.

Notice these important equivalencies as designated by the screened rectangles:

20# Bond is equivalent to 50# Book

24# Bond is equivalent to 60# Book

70# Book is equivalent to 70# Text

A common mistake (see War Story 14 on page 74) is to select 80# (or 80 lb.) weight, but to forget to designate whether the stock selected is text or cover. Because the basic size differs, 80# text is **NOT** equivalent to 80# cover.

If you compare an 8.5 by 11 sheet of 80# cover to an 8.5 by 11 sheet of 80# text, you will see that the cover is about twice as thick as the text.

<div align="center">

500 sheets, 20 x 26 500 sheets, 25 x 38
80 lb. cover stock 80 lb. text stock
weighs 80 lbs. weighs 80 lbs.

</div>

The Parent Trap

In addition to the basic size sheets for each type of stock, paper comes in different sizes of oversize sheets called parent sizes. Some finished size sheets are more economically cut from particular parent size sheets than others. That is, depending on the size of your finished sheet, there could be more waste with a particular size of parent sheet than another. Printers generally select the most economical parent size for your final sheet size.

If you select a nonstandard sheet size, such as 5 7/8 by 9 5/8, there may be a great deal of paper waste when the sheet is cut out of parent size, depending on the available parent sizes of the stock you have chosen. Another factor to consider is the direction of the paper grain (see page 85). Sometimes it is possible to get more sheets out of parent size, if some of the sheets are cut at right angles to each other. For some print orders, this type of cross cut is not a problem, but for books and other projects where it is important to have all the sheets running the same grain it may not be possible to use a cross cut, thereby resulting in lots of waste that you are unnecessarily paying for. If you have concerns about a particular trim size and the waste it will yield, ask for your printer's recommendations.

Table 5-5 shows how an 8.5 by 11 sheet is cut from two different parent size sheets. In this case, the 23 x 35 sheet yields less paper waste.

TABLE 5-5: AN 8.5 BY 11 SHEET CUT FROM TWO PARENT SIZES

23″

35″ *Eight 8.5 by 11 sheets can be cut out of this parent size with two strips* **1 x 23″** *and* **1 x 35″** *left over.*

25″

38″ *Eight 8.5 by 11 sheets can be cut out of this parent size with two strips* **4 x 25″** *and* **3 x 38″** *left over.*

Buying and selling stocks

After you place your order, your printer purchases your selected paper from one of his paper vendors. If the selected paper is a standard stock, it generally takes 1-3 days to obtain and is either shipped to a local paper store for pick-up or is delivered direct to the print shop location. If you have ordered specialty papers or custom envelopes, your paper order may take 2-3 weeks to arrive at the printer's. Make sure to consult with your printer about your scheduling needs before you place your order.

Some printers routinely stock 3-5 different sheets as house papers. A house line of papers might include a couple of 50 or 60 lb. offset papers for books, a line of designer text with matching cover stock for corporate or personal identity packages as well as a house coated book sheet for high-end brochures.

The printer establishes a house line of papers based on printability and availability. You can frequently save money by buying these house stocks, because the printer generally buys these papers in larger quantities thereby reducing the per sheet cost.

Through the looking glass——paper surfaces

Looking at papers under a magnifier reveals their many different surfaces. These surfaces influence ink holdout, printability, color vibrancy and the crispness of halftones. Surface and function must go hand in hand to determine the best paper selection for your project.

In the final steps of paper manufacture, paper is sent through machine rollers to make it smooth. As paper passes through each set of rollers, it becomes smoother and smoother. This process is called calendering.

WAR STORY: Darlyn tells us—I was coordinating a series of 11 by 17 flyers for educational seminars my company was hosting. I sent an individual specification sheet to my printer for each order. After a few orders, my printer asked me if I was planning to use the same 70# text for any more subsequent orders. When I told him the plan was to print 12 more sets of flyers throughout the year on the same stock, he said he could save me 20-30% by buying the paper in bulk, even though each print run of the job was different. Over the year, he saved me over $8,000 by making that suggestion. I was happy to supply him with a purchase order for the year's flyer purchases.

BATTLE PLAN: If you are planning to purchase a large lot of paper over a period of time, ask your printer to negotiate savings for you based on the total order.

Form ever follows function.

Louis Henri Sullivan

In addition to finishes that are created by different stages of calendering, there are also finishes, such as linen or laid, that are created by embossing with special steel rollers.

The quality of surfaces varies widely from paper line to paper line and sometimes even from lot to lot. If you gather some different paper samples with linen surfaces you will notice differences in how the linen surface has been embossed into the sheet.

Table 5-6 on pages 80-82 helps you match the function of your printed piece to the type of printing surface. This table provides information on the most common types of surfaces, but as you gain experience with paper samples you will notice that there are many other specialty surfaces that go in and out of vogue.

TABLE 5-6: FINISHES AND FUNCTIONS

Common Finishes	Good Features & Potential Challenges
Uncoated Papers Bond & Book } **Smooth** **Wove** **Vellum** (rough to smooth) **Smooth** paper has very little visible texture on its surface. **Wove** has a very slightly stipled surface. **Vellum** has a slightly rougher stipled surface than wove.	The smoother the finish, the better halftones and images will reproduce. Vellum paper has a rougher surface than smooth or wove so ink dries a little more quickly on it because more ink absorbs into the rougher fibers. A vellum texture paper for a book can sometimes be easier for collating because it generally marks less than a smooth stock. As paper runs through a collating machine, ink from the paper sometimes adheres to the collator rollers and marks up subsequent sheets that run through. So, if your book or multi-page project is going from printing to collating and binding on a tight schedule, vellum would be the best choice of these three textures. Vellum is slightly less see-through than smooth because of its texture. It also tends to bulk up more than smooth paper. If you wanted your 60-page business plan to appear more voluminous, vellum paper might be a good choice.

TABLE 5-6: FINISHES AND FUNCTIONS *continued*	
Common Finishes	**Good Features & Potential Challenges**
Designer Papers (uncoated) Text & Cover } **Felt** **Linen** **Laid** **Felt** paper has a bumpy, absorbent texture. **Linen** paper has a finish that looks similar to linen fabric. **Laid** finish has a bumpy horizontal pattern. Designer text and cover sheets are more costly than bond and book papers.	Felt finish paper has a bumpy texture that is absorbent. A felt finish paper may not be appropriate for a brochure that needs very crisp photos because the texture will soften the look of the photos considerably. Linen finish is an embossed finish that looks similar to linen fabric. One side may vary slightly from the other side. Regular linen finish stock sometimes causes problems for laserprinting. Laid finish paper has a bumpy horizontal pattern running through it. The direction or grain of this pattern must be specified for business cards and other applications because depending on how the paper is cut the pattern of the laid finish may not be running the direction you wish. There are special versions of laid and linen finish paper manufactured specifically for use in laserprinters. If you choose one of these surfaces for a brochure with photos, examine preprinted samples to make sure you like the softened effect.

TABLE 5-6: FINISHES AND FUNCTIONS *continued*

Common Finishes	Good Features & Potential Challenges
Coated papers 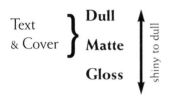 Printing on coated papers is more expensive than on uncoated papers. It requires more printer expertise, better equipment and more paper waste to achieve high-quality results compared to uncoated stocks.	Coated papers are the best for color vibrancy because the ink "stands up" on the sheet instead of absorbing into the fibers and drying down to a less vibrant color. Dull and matte surface coated papers are better for reading than gloss paper because they don't give off as much glare. If you have a brochure with extensive text as well as high-resolution images, these papers would be a good selection. High gloss stock is best for full color photos and dramatic images with limited text. The shine gives photos and images added vibrancy and drama. Coated papers are not a wise selection for any material where customers must write-in information and return it to you. The coated surface is not suitable for most types of writing implements. Uncoated papers are more appropriate for this purpose. Most magazines are printed on coated papers, but their return order postcards are printed on uncoated index stock.

Pulp Fiction—recycled papers

Using recycled fiber helps the environment by preventing the cutting of virgin trees. In the past few years, recycled papers have increased in popularity as consumers become more environmentally conscious. As a result of this increasing consumer demand, many types of recycled papers are now available, especially in the designer text and cover markets.

Recycled paper is made up of two types of fiber, preconsumer waste and postconsumer waste. Preconsumer waste is made up of paper trimmings, damaged paper and paper mill scraps. In general, preconsumer waste consists of paper that was never printed. Postconsumer waste is made up of paper that has been thrown away by the end user, such as printed paper bags, old telephone directories or any other paper that was preprinted and then recycled.

Most recycled paper is not made from 100% recycled fibers but is instead a combination of virgin and recycled fibers. If the amount of recycled fiber is important to you, read your paper sample books carefully. Most sample books list the percentage of preconsumer and postconsumer fibers for the recycled papers they display.

The majority of available recycled papers have flecks manufactured into them. These flecks vary in size from tiny "ecospots" to wavy lines. Whether a recycled paper is a good choice for your project depends largely on the graphics/type for that particular project.

Recycled papers tend to vary in color and fiber content more than other papers do, so from lot to lot there will be slight differences. These variances are true for all papers, but especially true for recycled papers because of the various sources of the recycled pulp. Also, no two recycled sheets with flecks are exactly alike, so if you are looking for uniformity, a recycled paper might not be a good selection. On the other hand, these papers are great for many designer looks. In combination with the correct

graphics and ink color they can yield many interesting effects because the color and fleck pattern plays a large role in the look of the finished piece.

Sometimes recycled papers are more expensive than nonrecycled stocks due to the need for removal of ink, color and coatings in the recycled materials before the paper is manufactured. The quality of recycled papers has improved considerably in the past five years, but a word of caution is important here. Poorly manufactured recycled papers can cause flecks from the paper surface to come off, causing dust problems in photocopiers and laserprinters. These dust flecks can go up into offset presses causing irregularities in ink coverage A piece of dust above the printing surface forms a white ring where ink does not lay down on the sheet. This type of printing problem is called a hickey.

WAR STORY: Jeff tells us—I designed a newsletter for #16 my student organization. The newsletter contained photos introducing eight new staff members to the organization. Our organization is dedicated to protecting the environment, so I picked a flecked recycled paper with the maximum amount of preconsumer and postconsumer waste content. When the newsletter came back from the printer, we weren't too happy with the outcome. The flecks in the paper made our staff look like they had chicken pox. We all laughed about it afterwards and we liked the stock and continued to use it, we just printed any photos on a separate smooth-surfaced insert. Our printer recommended a recycled paper for the revised insert that did not have many ecospots in its surface.

BATTLE PLAN: Ask your designer or printer if you are concerned about how a certain type of recycled paper will work for your finished piece. Photos and certain types of graphics are not always a good match for recycled papers with surfaces that have a large quantity of fibers or ecospots.

The Jagged Edge——paper grain

Paper grain, the direction the fibers run in paper, is an important factor to consider when purchasing paper. In this case, we are not talking about decorative fibers, but the majority of the paper fiber that has been used to manufacture the paper.

Suppose you are designing a brochure on a lightweight cover stock that trifolds to fit in a #10 envelope. You want the folds to be as smooth as possible, so you may want to make sure the folds are running parallel to the grain of the paper. Table 5-7 shows some examples where paper grain is a critical factor.

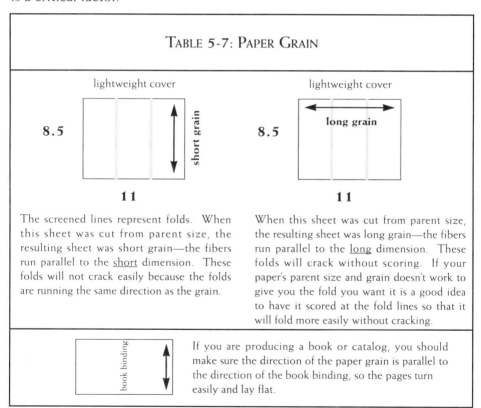

TABLE 5-7: PAPER GRAIN

lightweight cover lightweight cover

8.5 short grain 8.5 long grain

11 11

The screened lines represent folds. When this sheet was cut from parent size, the resulting sheet was short grain—the fibers run parallel to the <u>short</u> dimension. These folds will not crack easily because the folds are running the same direction as the grain.

When this sheet was cut from parent size, the resulting sheet was long grain—the fibers run parallel to the <u>long</u> dimension. These folds will crack without scoring. If your paper's parent size and grain doesn't work to give you the fold you want it is a good idea to have it scored at the fold lines so that it will fold more easily without cracking.

book binding

If you are producing a book or catalog, you should make sure the direction of the paper grain is parallel to the direction of the book binding, so the pages turn easily and lay flat.

The face people see——envelopes

No one will ever notice your service brochure, product announcement or grand opening sale if your envelope is never opened! A successful sales campaign depends upon an attractive envelope that will compel your target market to open it and find out what's inside.

If you are on a limited budget, it is crucial to make sure that your brochure or other sales material will fit in the outer envelope you wish to use. A standard size envelope is your best bet here. If you decide you want a custom envelope, remember that to get an envelope in a custom size you may need to order a quantity of 2500-5000 to be cost effective. Custom envelopes are more expensive than the standard envelope sizes and styles described in Table 5-8 on pages 88-89.

Generally, the only envelopes that are readily available in stocks matching designer letterhead papers are #10 envelopes and announcement envelopes in A2, A6, and A7 size with square flaps. Table 5-8 does not show the many hundreds of styles and sizes of available envelopes, it is simply a thumbnail guideline to the most commonly used and readily available sizes and styles.

Color My World

> With color one obtains an energy
> that seems to stem from witchcraft.
>> *Henri Matisse*

The most important thing to remember when choosing colors is that everyone perceives color very subjectively. In other words, what one person sees as red another person may see as orange! To further complicate matters viewing color in different lighting environments

changes the way the color looks. What seemed blue in bright light may appear purple in the lighting of an office environment!

flat or spot color versus process color

There are some basic differences between flat color and process color. Flat color or spot color is selected by using a color swatch book. The ink for flat color is purchased as a pre-mixed standard color or is custom mixed at the printer's. The color in flat color is created by laying the ink directly in blocks, design elements or screen tints on the page.

When you select a spot color you use a swatch book to select the 100% strength of the color and a color tint selector to select the screen tints you want, such as 10%, 20% or 70%. See Table 5-2 on page 69 for a refresher.

Unlike flat color, process color mimics the look of a full-color illustration or photograph. Process color is always composed of the same four ink colors, cyan, magenta, yellow and black, called CMYK for short. The look of process color is created by using overlapping dot patterns of these four inks in combination with each other. See pages 61-62 for a refresher.

Sometimes it is difficult to achieve the effects you want even with full process color. For example, if you had a company logo that consisted of two flat colors you might not be able to get close enough to those colors by using process colors to simulate them. For a full-color brochure including your logo you would use process color for the full color photos then print flat colors for your logo so you can match your logo colors exactly. This would make your job a six-color order.

One-color or two-color presses can print process color pieces, but a one-color press must print each of the CMYK inks as a separate print run. Two-color presses can print two passes at once, such as yellow and black in one pass, and then cyan and magenta in a second pass. The way the process colors are grouped to be printed on a two-color press varies depending on the image.

TABLE 5-8: THE FIVE MOST COMMONLY USED ENVELOPE STYLES

Commercial

Monarch

Monarch	3 7/8 by 7 1/2	Used for personal stationery available in whites and off-whites
#9	3 7/8 by 8 7/8	Standard white envelopes used to fit inside #10 envelopes where customer reply is needed
#10	4 1/8 by 9 1/2	Standard matching envelope for trifold 8.5 by 11 letterhead, available in widest array of designer colors

Window

| #9 | 3 7/8 by 8 7/8 | These standard white envelopes are generally used for invoicing and payments. The address shows through the window, thereby avoiding the need for double addressing. The #9 size fits inside the #10, so that the customer can send back a reply. |
| #10 | 4 1/8 by 9 1/2 | |

TABLE 5-8: THE FIVE MOST COMMONLY USED ENVELOPE STYLES *cont.*

 Announcement

A2 4 3/8 by 5 3/4

A6 4 3/4 by 6 1/2

A7 5 1/4 by 7 1/4

A very formal invitation might use all three envelopes. Notice that the A6 will fit inside the A7 for this purpose.

These envelopes are generally used for invitations and announcements. The A2 size fits inside A6 & A7 and is generally used to reply to invitations. The A6 & A7 sizes are used as the outer envelopes for invitation packages.

 Booklet

 Catalog

6 1/2 6 by 9

9 1/2 9 by 12

13 1/2 10 by 13

Booklet envelopes open on the long dimension and are called "open side"

Catalog envelopes open on the short dimension and are called "open end."

These envelopes are generally used for catalogs, presentation folders and other oversize items. The 6 1/2 size houses a 5.5 by 8.5 booklet perfectly. These white stock envelopes can be dressed up with color printing for a dynamic impact.

Remittance 3 1/2 by 6 1/2
These envelopes are used for donations/orders and are frequently stapled into catalogs.

A four-color press prints all four process colors with one pass through the press. Four-color presses achieve the best color quality, but sometimes a one-color or two-color press run by a skilled operator can yield close to the level of quality for much less cost.

There is a new six-color process developed by Pantone called hexachrome. As its name implies, the process uses six colors, the four process colors plus orange and green, in registration with each other to produce high-fidelity color. The hexachrome process simulates twice the number of PMS colors as process color does. As you would expect, this is an expensive process which is only used in the top presses in the country for high-end corporate uses, such as annual reports.

Table 5-9 on the opposite page summarizes the type of color processes and the expense level of each.

RGB versus CMYK

Computer monitors and television sets create their full-color images with a completely different process than offset printing. The images on computer monitors are made up of red, green and blue dots (RGB) created digitally by your screen pixels whereas full-color printed images are made up of cyan, magenta, yellow and black ink dots. Therefore, colors that you see on your computer monitor cannot be exactly duplicated by offset printing.

> **Attempt the impossible in order to improve your work.**
> *Bette Davis*

Ensuring color quality is a complex process requiring calibration of computer software and hardware to ensure that your full-color design translates into the desired offset press results. Along the way, color is produced using some or all of the following: scanners, monitors, laserprinters, linotronic systems, film, color proofing materials, printing

TABLE 5-9: COLOR PROCESSES & THEIR EXPENSE LEVELS

1-color	**black or one PMS color (not both)**	least expensive
2-color *clever use of two-color can give a multi-color look for less cost than process color*	**black plus one PMS color** *or* **two PMS colors (colors don't touch)** *or* **two PMS colors tight registration (colors do touch)** *or* **duotone, screens of two colors are registered together**	
3-color	**black and two PMS colors** *or* **three PMS colors**	
4-color process	**uses four colors at screen angles to each other, CMYK**	
5-color	**CMYK plus one PMS flat color**	
6-color	**CMYK plus two PMS flat colors**	
Hexachrome®	**uses six colors at screen angles to each other, CMYK plus orange and green**	most expensive

Note: You can print more than three flat colors at a time but depending on how the colors are registered together, it may or may not be less expensive than process color. Colors that print over each other or touch each other require tighter press registration than colors that do not touch on the page. If screen angles must be registered together such as in duotones or CMYK, this requires the tightest press registration. When you see a magazine or newspaper photo that is out of register it looks blurry.

plates and, finally, ink on paper. Each device and its accompanying process creates color differently and therein lies the problem!

There are many software calibration tools to address this challenge, but if you are not a graphics professional the best and easiest solution for flat color pieces is to just realize this fact and use a PMS swatch book and color tint selector to make your flat color selections. The proofing options for process color are more complicated.

The burden of proof

For process color, your proofing process should parallel your expectations of the job. If you are going from your design files to film output, there are two common methods of checking your final color quality: overlay proofs and integral proofs.

An overlay proof has a overlay for each of the process colors as well as any flat colors. These overlays are taped together on a board so that you can get an impression of how the final color will look. Because the film acetate used to create the color overlays has some color itself and because the thickness of the overlays casts the color as well as distorts the registration slightly, you will not get an exact match of how the color will look, but you will get to see whether the colors are "pleasing." For many jobs, these overlays are the best proofing method available for your budget. Printers and designers frequently refer to these color overlays by using the brand names of the materials used to create them, such as Color Key, Color Check and Cromacheck.

If you want to ensure that your design files will yield the exact match color you expect in the finished printed version, a more expensive color proof from the films may be necessary. This type of proof, called an integral proof, is similar to a full color photograph. It shows your design on a high-gloss photo paper as a composite print. These integral proofs are referred to by their brand names, such as Cromalin, Agfaproof and Matchprint.

One of the problems with integral proofs is that they sometimes look better than the finished printed pieces! Because the process used to create these proofs is photographic, it is difficult for the ink-on-paper process of printing to match this level of quality. Most presses have some dot gain from the spread of ink as it goes down on paper, making the finished printed piece slightly darker and less crisp than your integral proof. If you adjust the proofs for this problem, then the proofs frequently look too pale!

Another problem with integral proofs is that they are generally printed on a high-gloss photographic paper. If your job is going to be printed on an uncoated paper the color quality will be more muted than the original proof depicts.

Some presses are set up to take digital files directly to printing plates without any film output. If your job is going to be printed using this type of press, then you may want to obtain a quick digital proof from a color output device, such as a color laserprinter, to check elements on the page and the general color relationships to make sure the colors are pleasing. If you want a more exact color proof, called a match proof, you or your designer should take your files to a service bureau to obtain a high-end color digital proof.

If your print job requires the highest level of color proof, in addition to the prepress proofing methods described previously, you may want to request a press proof. A press proof is a finished sheet right off the press for your sign-off. Since press time is interrupted while you are examining and approving your proof, these proofs require advance scheduling and a very high-end budget. Also, if you find a problem at this stage not due to the printing that could have been corrected at an earlier stage, it will be very expensive to correct.

Proofing methods and materials are constantly improving, but keep in mind that no proof will be an exact duplicate to your printed piece the day and hour it comes off the press.

Matching accessories to your color scheme

In addition to your corporate image on paper, your company logo, style and color scheme may appear on many other types of materials, such as vinyl, plastic, wood, cloth or steel. The material and methods you use for imprinting these different surfaces will have an impact on how well your company color matches from application to application. If your company imprints its logo on packaging or products, you may want to have modified versions of the logo so that instead of accepting a poor color match, you have more appropriate choices for certain types of applications. Imprinting color for every company identifier may not wise or financially feasible!

WAR STORY: Karen tells us—We just designed a new #17 logo for our company. I selected a paint color for all the vehicle signage and we were really happy with the way it turned out. As soon as our new corporate stationery was designed we took it to our local printer and asked him to match the logo color to the paint on our trucks. We were disappointed to find out that he couldn't find or mix an ink that was an exact match to the new paint.

BATTLE PLAN: When you are planning a corporate color makeover, check with all the vendors you are using to see if they can match a particular color. Remember that ink, vinyl, paint, plastics and fabric all require different color processes so exact matches may not be possible.

Choosing colors is an exciting, emotional experience. Color represent feelings, stand for symbols, create moods and influence your audience to buy or not to buy from you. No matter what budget you have to work with, color can add drama and flair to your printed pieces. With some

creativity and a smartly executed design, a brochure with varying screens of the same color, can have the style of a much more expensive multicolor piece. Cost effective two-color work can be achieved for offset runs of 2500 sheets or less. Even process color work has become much more affordable over the last five years because of new prepress methods.

Table 5-10 shows a planning chart for one company's printing needs. Notice how the expense categories were determined by the function of the printing pieces for their annual budget of $12,000.

TABLE 5-10: ANNUAL PRINT BUDGET—BLUE LIGHTENING THEATER

item	colors	function	budget
corporate stationery	logo in blue type in gray	sales letters/ direct mail	$2500 for 15,000 total pieces
flyers/insert in local paper	blue ink only	wide audience image ad	$3500 for 50,000 8.5 by 11, offset
event catalog	process color	targeted mail to client base	$4500 for 10,000 11 by 17 gloss
invitations	logo in blue type in silver	thank you to local patrons	$1500 for 750 panel cards and envelopes

Take the time to review your annual printing budget. By planning carefully, you can ensure that you will be able to use color to give your most important printed pieces the "dressing" they deserve.

Key Terms

The following key terms are found in this chapter. See the glossary at the back of the book for detailed definitions.

basic size (page 74)

basis weight (page 74)

bond paper (page 71)

book paper (page 71)

brightness (page 71)

bulk (page 71)

calendering (page 78)

coated both sides/C2S (page 73)

coated one side/C1S (page 73)

color swatch book (page 66)

color tint selector (page 68)

cover paper (page 71)

dot gain (page 93)

dull finish (page 82)

ecospots (page 83)

felt finish (page 81)

flat color (page 87)

gloss finish (page 82)

grade of paper (page 74)

grain (page 71)

hexachrome (page 90)

hickey (page 84)

house papers (page 78)

integral proof (page 92)

laid finish (page 81)

linen finish (page 81)

matte finish (page 82)

opacity (page 71)

overlay proof (page 92)

parent sizes (page 76)

postconsumer waste (page 83)

preconsumer waste (page 83)

process color (page 87)

ream (page 74)

recycled (page 71)

RGB (page 90)

specification sheet (page 79)

spot color (page 87)

text paper (page 71)

uncoated papers (page 66)

vellum finish (page 80)

watermark (page 71)

weight (page 71)

wove finish (page 80)

PUTTING *all* IT TOGETHER

Every exit is
an entry
somewhere else.

Tom Stoppard

Congratulations! Your project is ready for press. In order to obtain comparison quotes you will need to specify every aspect of your project *in writing*. Once you specify or "spec out" the details you will be able to compare 2-3 quotes to determine which printer will be the best vendor for your project.

The devil is in the details

This chapter provides a review of all the details you need to summarize in order to obtain printing quotes. At the end of the chapter, there is a filled-in quote form so that you can see how a sample project was summarized for quoting.

The numbers at the left of each explanatory paragraph correspond to the form so that you can see how the information is filled in. This form is only a sample...you may want to create your own form or modify the form supplied. You can also order blank forms direct from the publisher at www.leapingantelope.com, click on Web Store 2000, then follow the link to designer kits.

1 **Contact Information**—Your quote form should begin with your name, your company name and address and any other appropriate information, such as your phone number, fax number and e-mail address. Make sure to tell the printer when your quote is needed, the date you expect to bring your job in and the date you expect to receive your finished printing.

2 **Prepress Specifications**—There are three different ways you can supply materials to be printed: paper output, films or electronic files. If your job does not require halftones over 100 lpi (see pages 53-54 for a refresher) you can supply "camera-ready" paper printouts from your laserprinter. The printer takes your laserprints, places them on a platemaker and shoots an image of each page to create a printing plate for that page. This process is similar to taking a photograph of the page, thus the wording "camera-ready."

If your job has a second color, you would need to supply color-separated laserprints. All the laserprints will be black and white, but the color elements will be on one printout and the black elements will be on another printout. Table 6-1 shows an example of how laserprints would be supplied to reproduce a two-color page. Once these laserprints are made into printing plates, the color and black will be "registered" together on press to create the finished page.

If your job requires halftones of over 100 lpi, you will need to supply films to your printer. In any case, the same rule for color separations applies. If your job is two-color, there will be two films needed for every page that is to be printed two-color. For a process color job, there will be four films necessary for every process color page—one film for each of the process colors, cyan, magenta, yellow and black. If you have a print job with 4 process color pages, there will be 16 films needed—cyan, magenta, yellow and black for each of the 4 pages. As with paper printouts, because the films all look the same, the ink color should be designated outside the print area.

TABLE 6-1: SUPPLYING LASERPRINTS FOR A TWO-COLOR JOB

A feeling of
liberation swept
over her daily
thoughts as she
imagined her new life
without him.

▶▶▶▶▶▶▶▶▶▶▶▶▶▶▶▶▶▶▶▶▶▶▶▶▶▶▶▶▶▶▶▶▶▶▶

Broken Hearts

His deceptive deeds had done their damage. She didn't feel the same way about him anymore. Now that it was finally happening, she felt a shaky sense of serenity she hadn't experienced before. A feeling of liberation swept over her daily thoughts as she imagined her new life without him.

She was trying to take it slowly, step-by-step she kept telling herself. But, like a newborn colt, her legs crumpled under the weight of the adventure ahead.

laserprint for red plate

Your printout is black and white.

laserprint for black plate

Broken Hearts

A feeling of
liberation swept
over her daily
thoughts as she
imagined her new life
without him.

▶▶▶▶▶▶▶▶▶▶▶▶▶▶▶▶▶▶▶▶▶▶▶▶▶▶▶▶▶▶▶▶▶▶▶

His deceptive deeds had done their damage. She didn't feel the same way about him anymore. Now that it was finally happening, she felt a shaky sense of serenity she hadn't experienced before. A feeling of liberation swept over her daily thoughts as she imagined her new life without him.

She was trying to take it slowly, step-by-step she kept telling herself. But, like a newborn colt, her legs crumpled under the weight of the adventure ahead.

The finished printed page is two-color.

Don't forget to tell your printer which of your two laserprints is supposed to be printed in color!

You or your designer should supply a mock-up of your job to the printer. A mock-up is a rough representation of the job. For example, if you are printing a newsletter or booklet you should supply the printer with a black and white paper version to review. You can mark where spot colors or full color photos will appear.

Computer disk files, such as floppy disks and zip disks, are another way you can supply artwork to your printer. A printer who can handle these electronic files either takes them out to a service bureau for film output or acts as a service bureau himself. If you choose to go this route, consult with your printer to make sure he has compatible hardware (PC Windows or Apple Macintosh) or software (Adobe Illustrator, Quark-

XPress, Adobe Photoshop, Adobe Pagemaker) in the same version you have. Make sure to supply all fonts, graphics, photos and images on disk otherwise your printer will not be able to print out your file! It's also important to specify the lpi of your final photos.

The resolution you expect for photos and images controls both the supplied files you give to your printer as well as the type of plates the printer uses for the finished job. If the job does not require over 100 lpi, you can supply color separated laserprints, which will become silvermaster plates. If you want your output to be over 100 lpi, such as full-color photos you have specified for 133 lpi, then you or your printer will obtain film output that will be made into metal plates. Electronic files can be output to films and then to metal plates or to a direct laserplate (no films are generated) system either at lower or higher resolution. Table 6-2 lists some of the differences between silvermaster and metal plates.

TABLE 6-2: SILVERMASTER AND METAL PLATES

silvermaster plates	**metal plates**
are generated from positive camera-ready laserprints and are suitable for	are generated from film negatives and are suitable for
• short print runs	• long print runs
• one or two color	• one to process color
• low to medium resolution	• high resolution
• under 100 lpi images	• over 100 lpi images
• nonarchival purposes	• archival purposes
• tight budgets	• high-end budgets
• print-on-demand needs	• tight registration
	• multiple exposure images

3a **Printing Specifications**—Specify the type of project you are printing. Is it business cards? A flyer or brochure? Or is it a project with numerous pages, such as a newsletter, booklet or catalog? If you have several projects, it is important to provide a different quote sheet for each project.

3b Specify the final quantity. For example, if you want a finished quantity of 2500 booklets, it would be a good idea to get quotes for 1000, 2500 and 5000. Cost efficiency breakpoints for printing are generally in multiples of 500.

Keep in mind that if you order 2500 booklets you may end up with as few as 2250 or as many as 2750, 10% under or 10% over, respectively. If you need a guaranteed final quantity, make sure to let your printer know. Also, many printers charge for overruns. One press may charge you for 2500 but produce 2750, while another may charge you for 2500, but only provide 2250! A third press may provide you with 2750, but charge you for them instead of the ordered quantity of 2500. As you can see, you can easily be mislead by the quote numbers if you do not specify carefully.

3c The final size, or trim size, of your project needs to be specified. When you have a booklet or other multi-page project, as the number of pages increases the edge opposite the binding looks ragged as pages stick out at different angles. To avoid this messy look, printers cut the facing edge of the booklet to make it straight. This is where the terms "face trim" and "trim size" come from. Table 6-3 compares two booklets, one that is face trimmed and one that is not.

Standard final trim sizes are 5.5 by 8.5 and 8.5 by 11. If you specify a final size of 5.5 by 8.5 and also request face trimming, your booklet will actually be a little smaller due to the face trimming. You can request a final trim size that is not standard, but keep in mind that some nonstandard sizes are not very cost efficient, so if you have concerns ask your designer or printer.

TABLE 6-3: TWO BOOKLETS, ONE FACE-TRIMMED, ONE NOT

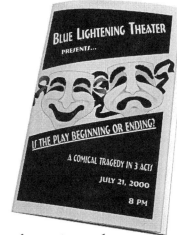

face trimmed **not face trimmed**

If you have an insert for your newsletter or catalog, make sure it's a size that will bind well and not stick out! (see page 9—Chapter 1). Also, make sure to indicate the size you need if you are getting a quote for envelope printing. See pages 88-89 in Chapter 5 for a refresher on envelope sizing.

3d **Number of Pages**—Some projects are easy, such as one 8.5 by 11 sheet of letterhead, printed 20,000 times, but many projects are multi-page and need to be specified carefully. For example, let's say you have a newsletter. It is 16 numbered pages, but it is printed on 11 by 17 paper and then folded down and stapled to a final size of 8.5 by 11. In order to print a newsletter this way, four 8.5 by 11 pages are printed on one flat of 11 by 17, two pages on one side and two pages on the other. In fact, all booklets or newsletters that are printed this way must have page counts in multiples of 4. If you have a 10-page newsletter, you will have to use three 11 by 17 flats to create it, so you will have two blank pages.

Fold four 11 by 17 sheets together and then number each page in your mock-up. Now, pull the pages apart. You will notice that page 16 and page 1 are on the same flat. If you or your designer do not set up the pages this way then your printer must do it. This process of stripping pages on flats so they print and bind in the correct order is called "page imposition." Table 6-4 shows how a 16-page newsletter is prepared page imposed. Notice that for a 16-page newsletter, the page numbers of each flat add up to 17. Also, the odd numbers are always on the right.

Most book or catalog printers print books in multiples of 32 pages called signatures. Because these signatures are folded and gathered in these 32 page increments they are called "f and gs." A catalog of 192 pages would be 6 x 32 pages or 6 signatures. If the catalog only had 188 pages, then 4 pages would be blank. Look carefully at some of the books you have on your shelf and you will see how many books have blank pages at the beginning and end. Don't forget to include any roman numeral pages in your count!

3e **Paper Selection**—Specify the paper by listing its brand name as well as its weight, texture (finish) and color. For example, Neenah Classic Crest (brand name), 24 lb. writing (weight), smooth (finish), natural white (color).

If you are open to the printer suggesting an alternate stock, indicate that on your quote form. Cost efficiency and availability are two reasons printers suggest alternate stocks. Just make sure that if a printer has quoted on an alternate that is comparable to the paper you selected and not a substitute of lesser quality.

4a **Color Selection**—Specify the number of ink colors in your finished project. If your project has spot colors specify the Pantone Matching System (PMS) color/s. You also need to specify the number of pages where the colors are being printed. Any special color elements should be noted for the printer. Table 6-5 provides an overview of color terminology important for obtaining quotes.

TABLE 6-4: A 16-PAGE NEWSLETTER, PAGE IMPOSED

front of flat		*back of flat*	
page 16	**page 1**	**page 2**	**page 15**
page 14	**page 3**	**page 4**	**page 13**
page 12	**page 5**	**page 6**	**page 11**
page 10	**page 7**	**page 8**	**page 9**

TABLE 6-5: COLOR TERMINOLOGY

Duotones—A true duotone is made up of two photos that are tightly registered at different screen angles to create the finished image. Real duotones require exacting color registration on press and ar e more costly to produce than fake duotones.

Blocks of color—Any flat blocks of 100% color should be noted. The larger the block of color, the more expensive. Many offset presses cannot print an 8.5 by 11 full block of 100% color and achieve a consistently smooth look.

Bleeds of color—If color ink goes all the way to the outer edge of the sheet, this is called a color bleed. Since presses cannot print ink all the way to the edge of the sheet, printers achieve this look by running the job on oversized stock and then trimming to the edge where the ink is printed. Bleeds run up the expense of your project because oversize paper must be used and because of the extra trimming work involved.

Overprinting, trapping and knockouts of color—When two colors are tightly registered together or when 2 colors print one over another, overprinting, trapping and/or knockouts must be designed properly.

Overprint—If you are printing black (or another very dark color) over a light color, you can achieve the results you want by just overprinting the black over the light color.

BLACK

TABLE 6-5: COLOR TERMINOLOGY *continued*

Trapping and knockout—Suppose you want to print a light green circle inside of a black square. If you overprint the circle over the square, it won't show because the color is too light. If you **knockout** the image on the black square, black ink won't print in that spot, so that when the green ink prints there it will show up as the green color you want.

If you knockout the circle in the square the same exact size as the circle you overprint, and your press doesn't register the two colors exactly, a thin white line will show up. To avoid this press problem, you need to prepare a **trap** where both colors overlap. You can make the overprint circle slightly bigger than the knockout circle to ensure that no white will show even if the press registration is not perfect. The overprint circle is *spread* slightly larger than the knockout circle. The black ink defines the edge of the circle even though if you use a magnifier you will see some light green ink that has overprinted the black.

green and white circles are the same size, causing registration problems

green circle is spread larger than knockout so it traps properly

4b **Varnish**—If your project requires varnish after printing, indicate so on your quote. Varnish is a clear, transparent coating that is printed as a sealant after all ink printing is complete and totally dry. Varnish is used to add shine to select design elements or to an entire sheet. It is also used to help protect printed surfaces from damage due to use.

4c **Color Quality**—Many print shops can handle quality 2-color work, but when the work advances to process color you should indicate the level of quality you expect.

There is some variance from sheet to sheet on process color work. Some variances are so slight that a person who is inexperienced in the use of color would not even notice them. For most process color work aesthetically pleasing color will be workable. For some high-end uses, such as an annual report with a precise color for a company logo, exact match color may be required. Exact match color is a very costly process and should not be requested unless your project requires it and your budget allows for it! If your job requires a prepress proof or a press proof, make sure to specify that as well (see pages 92-93 for a refresher).

5a **Finishing Services**—If your project requires die cutting, foiling, embossing (see page 18 for a refresher) or folding, you will need to specify these finishing services on your job specifications. All these special services incur additional cost and time. Table 6-6 shows some of the more common types of folds requested. If your job requires folding it's always a good idea to bring a mock-up to your printer.

5b **Bindery**—If your project needs to be stapled, plastic comb bound, wire-o bound or perfect bound, specify the type of binding on your quote sheet. Booklets are frequently stapled or saddlestitched using a bookletmaker that folds as well as staples. The staples used in these machines are sturdier than your typical desktop stapler.

Plastic comb or wire-o binding is used when it is important for the pages in a book to lay flat. Plastic comb is less expensive than wire-o and is frequently used for cookbooks and workbooks. Wire-o is frequently used

TABLE 6-6: COMMON STYLES OF FOLDS

french fold

baronial fold

double parallel fold

z fold

gate fold

letter fold

roll fold

center fold

for software manuals. Most books that you find in a bookstore or library are bound using a glue and/or stitch method called perfect binding. This book, for example, is perfect bound. Table 6-7 shows some of the typical types of bindery.

6 **Packaging and Shipping Instructions**—Sometimes it is important to have materials packaged in a certain way. If you are concerned about moisture, you may want your printer to shrinkwrap your letterhead in quantities of 250 or 500. Books can also be shrinkwrapped individually or in multiple quantities.

If your job is a small order you may want your printer to call you when it is finished so you can pick it up. If so, you will want to designate your order as a "will call" order. On the other hand, if your order is large, it might be more convenient for you to check your job at the printer's and then have the printer direct ship to your mailhouse of choice or some other destination.

Pages 112-118 provide you with an example of a filled-in printing specification sheet that is ready to fax to various printers to obtain competitive bids. If you would like 8.5 by 11 blank forms for your own print quotes, you can order them direct from the publisher at www.leapingantelope.com.

Remember that obtaining print quotes is only part of the process. If you obtain five quotes, one very high, three about the same and one very low you may want to ask more questions, obtain printing samples or go on site to check out your printer before making a decision. Review the chart on page 21 for a refresher. Once you find appropriate vendors, it isn't necessary to bid out every print job. It is a good idea to periodically bid jobs out to make sure that your vendor/s prices still fall into the competitive category.

Preparing well-detailed job specifications takes practice, but it frequently uncovers potential problems before you hand your job over to press. It also helps you to manage your projects for savings, schedule and quality.

TABLE 6-7: COMMON TYPES OF BINDERY

perfect binding

wire-o binding

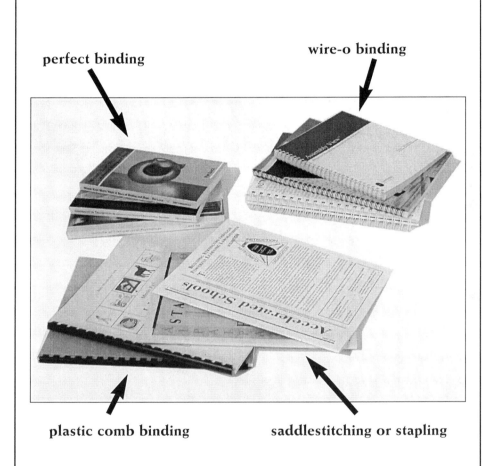

plastic comb binding

saddlestitching or stapling

REQUEST FOR QUOTE—PAGE 1

1

contact information

Leaping Antelope Productions

company name

231-C South Whisman Road

Mountain View, California

company address

Ann Goodheart

contact name

650-969-3943

phone number

650-969-3945

fax number

print123@leapingantelope.com

e-mail

11/20/2000	*11/28/2000*	*12/20/2000*
date quote needed	job to printer	expected delivery

Please provide us with a 2nd quote

for rush delivery by 12/5/2000.

customer comments vendor comments

2

prepress specifications

CUSTOMER TO SUPPLY:

☐ laserprints ☑ mock-up

☑ color separated laserprints

☐ film

☐ service bureau to supply film contact:_____phone:_____

☑ electronic files to be supplied based on printer specifications

electronic files supplied for

high-resolution cover only

customer comments vendor comments

REQUEST FOR QUOTE—PAGE 4

4a
printing specs color selection

COLOR SELECTION *CONTINUED*

project contains:

☐ duotones ☑ blocks of color ☐ bleeds of color

☐ trapping/knockouts

COMMENTS
heavy ink coverage on cover only

4b
printing specs varnish

VARNISH

project contains:

☐ spot varnish

☐ sheet varnish

4c
printing specs color quality

COLOR QUALITY FOR PROCESS COLOR

☐ pleasing color ☐ match color

proof requested:

☐ overlay proof

☐ integral proof

☐ press proof

5a
finishing

FINISHING

project requires:

☐ die cutting

☐ foiling

☐ embossing

☐ folding

5b
bindery

BINDERY

project requires:

☑ stapling/saddlestitching

☐ plastic comb

☐ wire-o

☐ perfect binding

6
shipping

SHIPPING

☐ shrinkwrap

☑ will call

☐ deliver to _____

other packaging/shipping instructions:

customer comments vendor comments

115

Key Terms

The following key terms are found in this chapter. See the glossary at the back of the book for detailed definitions.

bleed of color (page 106)

block of color (page 106)

camera-ready (page 98)

color-separated laserprints (page 98)

duotone (page 106)

exact match color (page 108)

face trim (page 102)

knockouts (page 106)

metal plates (page 101)

mock-up (page 100)

overprinting (page 106)

overruns (page 102)

page imposition (page 104)

perfect binding (page 110)

plastic comb binding (page 108)

pleasing color (page 108)

saddlestitching (page 108)

signatures (page 104)

silvermaster plates (page 101)

"spec out" (page 97)

trapping (page 106)

trim size (page 102)

varnish (page 108)

wire-o binding (page 110)

Office of the Future

The computer is down. I hope it's something serious.

Stanton Delaplane

The paperless society…will it ever happen? Today's office work flow is a high-speed combination of print and electronic media. Technology hasn't decreased the amount of paper in our offices, it has only increased the speed by which we produce it! Office professionals are sometimes expected to write, edit, design and present finished printed products in less than 24-48 hours. In addition, those same printed materials are converted to electronic files for communication as well as data retrieval.

speed, speed, and more speed

None of us can predict the future, but we can extend current trends to see a clearer picture of the office of the future. One trend is clear—computer speed will continue to have a major impact on the workplace. Faster computers with CPU's of 400-750 megahertz will handle complex tasks such as enhancements on large image files. For example, suppose you want to use Photoshop to design a process color photo collage for the cover of a brochure. You might be hesitant to tackle that project right

now, because the computer you have in your office might have trouble with the large file sizes required to produce such a high-resolution image. If you had a computer system that could easily handle the large image files, you might consider changing the hue, color and saturation of a large 60 megabyte process color file yourself. Combining photographs to make a collage would be a feasible office project if it took only seconds, instead of minutes.

it flies through the air with the greatest of ease

Let's say you've successfully finished the Photoshop design of your brochure cover. Now you have a logistical problem. Your boss is on business in Tokyo and she insists on seeing your color version before it is released to press. It's 3 o'clock in the afternoon in your office in Eugene, Oregon and she is going into a meeting in Tokyo at 9 am.

There is no time to lose. You move over to the computer system that is online all the time because it has a cable modem or, better yet, DSL hookup (digital subscriber line). You download Adobe Acrobat software from Adobe's website, save your file as PDF (portable document format) and then send it over the internet to your boss in Tokyo.

Your boss receives the file in a few seconds after you send it. Your boss is a little sleepy, because it's 8 am in Tokyo, but she isn't too sleepy to catch a typo on your brochure cover! She types a quick e-mail back to you and asks you to fix the typo, add another two lines of copy, alter the color of your company logo so that it's a little denser and then forward the cover over for one final review. She says she will give you the green light signal if it is OK.

Now you're back at your desk, revising the file. To save more time, you talk out loud to your CPU and ask it to check the spelling of three more words in the two new lines your boss asked you to add. Meanwhile you revise the color of the logo, fix the typo and then add in the two new lines

118

including the correct spelling that your CPU voices back to you. You've programmed your CPU to sound like Mel Gibson.

In less than 5 minutes you have made the requested changes and forwarded the file back to Tokyo. In a couple of minutes you see the traffic signal icon on your desktop flashing a green light. Your boss was on her way to the meeting so she signaled you from her beeper to let you know the file was OK to send to your print vendor.

Does this scenario sound too farfetched to you? Well, maybe just the Mel Gibson part. Actually, all the tools in this scenario are already being used in today's global workplace. The future will bring improvements in speed, file transfer and file flexibility that will make the previous example commonplace in both commercial and home offices.

one file used five ways

Now that your cover has been given the official seal of approval from your boss, it's ready to send over to your printer. The modern printer is a file conversion specialist who is comfortable with both print and electronic media as well as the vast varieties of software and hardware needed to produce the best results for customers.

You e-mail the cover over to your printer and ask him to look at the file and determine if there are any adjustments needed for a large run of 20,000 process color brochures. This new cover will replace a previous cover but the interior of the brochure will remain the same as a printed piece you produced last quarter. "No problem," says your printer. "The last brochure is here in our digitized archive. We'll just replace the cover and make a few color adjustments so that it prints optimally."

The cover will also be needed for a shorter print-on-demand purpose as well. You will need to add a few words to customize the cover for a training manual. The 50 training manuals will be needed for a regional

sales meeting in Eugene in a couple of days. Your printer produced this manual about 6 months before, but the spreadsheets for sales goals will need to be revised and inserted into the previous document.

You ask "When do you need the sales goals figures for those insertion spreadsheets?" You're concerned because you still don't have the figures from the regional sales manager and there isn't a final head count for attendees at the training event either.

Your printer says you can e-mail the figures over about 2 hours before you need the final manuals. He will make the necessary color adjustments for the cover to be run on his short-run digital copier and produce the covers as well as the rest of the interior of the training manuals while you are obtaining those final figures. He just needs the code number of that training manual so that he can access it from the on-site digital archive.

Now there are still a couple of miscellaneous items. You need the cover to be blown up to a large full-color poster size so that it can be mounted on a board and placed on an easel for the sales meeting. A transparency version of the image would be nice for use on an overhead projector at the start of the sales presentation. Could he supply these items in the next two days and send a copy of the file appropriately converted for your web/multimedia designer who is working on the sales presentation out of her home office in Florida? "No problem," your printer says. "We can handle it."

You have now used your Photoshop file in five different ways: a process color brochure cover produced on an offset or digital press, a training manual cover for a short run of customized manuals produced on a color copier or other short-run digital output device, an image for a large format poster, a color transparency and a splash screen for a web or multimedia sales presentation. And all of these different projects have been arranged before the end of the same day your boss made her final corrections!

Tomorrow when you get to the office a new challenge awaits you. Your boss has thrown a new hurdle in your path!

customize for your customers

No passion in the world is equal to the passion
to alter someone else's draft.

H. G. Wells

The traffic getting to your office is a little heavier than usual today so you decide to check your e-mail on your palm pilot. Your boss has sent you an urgent note. If she sends you a high-resolution photo of the Tokyo skyline could you modify your photo collage and send it back in time for her to use it as part of her sales presentation? She really loves your work on the image, but it would be more effective for customers in Tokyo if it were customized for them. Could you find out the Japanese characters for "business collaboration" and place them in the image as well?

Aren't you sorry now that your office pitched in to buy her that 2 million pixels per inch digital camera for her birthday? You send her back a quick note to let her know you will get it out within a half hour of your receipt of her photo. You will remind her of this day during your next salary evaluation. There is also an e-mail from the regional sales manager. He is going to need 70 training manuals instead of 50. You send a quick e-mail to your printer to let him know about the increased quantity.

Back at the office, you tap into the company's international online dictionary to find the Japanese characters for the words "business collaboration." In the meantime, your boss has sent over her digital photo files of the Tokyo skyline via e-mail. She has actually sent a folder with 4 images and she is leaving it to you to choose the one you think will work best. The files are high-resolution EPS (encapsulated postscript) but they have been compressed to go over the DSL more rapidly.

You use a special software program to unstuff the photo files. Two of the files she has sent are perfect, so you decide to send her two different

versions of the redesigned file. Also, she didn't mention to you how she was planning to use the image, so you decide to save it in several different file formats—high-resolution for print output and lower resolution for web and internet presentation.

You float an e-mail over to a colleague who speaks and writes Japanese fluently to make absolutely sure your Japanese characters for "business collaboration" are correct. She responds to your request quickly to let you know you are OK with the characters. Then, you e-mail the completed files back to your boss. You feel confident that she will like what you have done. Now onto the next project!

As you can see from this scenario, the office of today and a few steps into the future is a very challenging environment. You will be preparing copy and designs for many different types of production processes and you will be asked to do so in tighter and tighter timeframes to meet the needs of the demanding global marketplace. Your advanced office tools and knowledge will give you more control than ever before over various phases of your project.

As you work with designers and printers, you will be requesting expertise from them in both print and electronic media. In addition to the more traditional forms of design and printing, these craftspeople of the future will need a thorough knowledge of file conversion, information storage and data retrieval as well as a commitment to customizing print and electronic media suited to the quality, budget and time constraints of their clients. They must be able to troubleshoot problems with hardware, software and file configuration and still keep jobs on schedule. You can help their jobs go more smoothly by communicating with them to continually refine your file submission methods and to proofread carefully so that your copy is as error free as possible.

The office of the future is an exciting, demanding work environment. We hope this book has provided you with some of the tools you will need to master that environment.

TRENDS TO WATCH

Faster CPU's, 400-750 mhz will handle complex tasks such as picture enhancements on large image files.

High speed data transfer from digital cameras and video cameras will translate into greater file resolution, higher quality images. Digital cameras that capture 2 million pixel per inch images will become the norm for professionals as well as ordinary consumers.

Larger capacity storage devices both stationary and portable will accommodate these high-resolution, large-memory image files. In addition to zip, CD-ROM and DVD storage alternatives, new storage media will provide the possibility for storage of large files.

File conversion possibilities will increase but it will become easier to convert files into different formats for a wider base of print and electronic uses.

Faster and more reliable web files will travel over the internet, increasing the need for cable modems and DSL in every commercial and home office. It will be easier and much faster to send large art files to service bureaus, designers and printers over the internet.

Adobe PDF files and other similar file formats will make it easier to read and convert files from print media to files that can be used in web and multimedia formats.

Higher quality, less expensive, digital output devices, such as color laserprinters and copiers, will increase in resolution and in speed (pages per minute—ppm) so that commercial and home offices can produce customized short print runs from their own desktops.

Key Terms

The following key terms are found in this chapter. See the glossary at the back of the book for detailed definitions.

CD-ROM (page 123)

CPU (page 117)

DSL (page 118)

DVD (page 123)

EPS (page 121)

high-resolution images (page 118)

megabyte (page 118)

megahertz (page 117)

multimedia (page 120)

PDF (page 118)

pixels per inch (page 121)

ppm (page 123)

print on demand (page 119)

splash screen (page 120)

web (page 120)

zip (page 123)

APPENDIX A EQUIVALENT WEIGHTS TABLE

Equivalents for	Book 25 x 38	Bond & Writing 17 x 22	Cover 20 x 26	Vellum Bristol 22 1/2 x 28 1/2	Printing Bristol 22 1/2 x 35	Index 25 1/2 x 30 1/2	Tag 24 x 36
Book	30	12	16	20	25	25	27
	33	13	18	22	27	27	30
	35	14	19	24	29	29	32
	38	15	21	26	32	31	35
	40	16	22	27	33	33	36
	45	18	25	30	37	37	41
	50	20	27	34	41	41	45
	55	22	30	37	46	45	50
	60	24	33	41	50	49	55
	65	26	36	44	54	53	59
	70	28	38	47	58	57	64
	75	30	41	51	62	61	68
	80	31	44	54	66	65	73
	90	35	49	61	75	74	82
	100	39	56	68	83	82	91
	120	47	66	81	99	98	109
Bond & Writing	33	13	18	22	27	27	30
	36	14	20	24	29	29	32
	38	15	21	26	32	31	35
	41	16	22	27	34	33	37
	46	18	25	31	38	37	42
	51	20	28	34	42	42	46
	61	24	33	41	51	50	55
	71	28	39	48	59	58	65
	81	32	45	55	67	67	74
	91	36	50	62	76	75	83
	102	40	56	69	84	83	92
Cover	46	18	25	31	38	37	42
	64	25	35	43	53	52	58
	73	29	40	49	61	60	66
	91	36	50	62	76	75	83
	100	40	55	68	83	82	91
	110	43	60	74	91	90	100
	119	47	65	80	98	97	108
	146	58	80	99	121	120	133
	164	65	90	111	136	135	150
	183	72	100	123	151	150	166
Vellum Bristol	99	39	54	67	82	81	90
	158	58	81	100	123	121	135
	178	70	97	120	147	146	162
Printing Bristol	133	52	73	90	110	109	121
	151	59	83	102	125	123	137
	181	71	99	122	150	148	165
	211	83	116	143	175	173	192
	241	95	132	163	200	198	219
	271	107	149	183	225	222	247
Index	110	43	60	74	91	90	100
	135	53	74	91	112	110	122
	170	67	93	115	141	140	156
	208	82	114	140	172	170	189
Tag	110	43	60	74	91	90	100
	137	54	75	93	114	125	125
	165	65	90	111	137	135	150
	192	76	105	130	159	158	175
	220	87	120	148	182	180	200

Basic weights appear in bold type.

BIBLIOGRAPHY/RECOMMENDED READING

Also see page 45 for additional resources related specifically to typography and desktop publishing.

Adobe Illustrator 8.0: Classroom in a Book, by Adobe Creative Center, Adobe Press: October 1997—a thorough hands-on guide with short, focused lessons for beginning users of Adobe Illustrator 8.

The Chicago Manual of Style, University of Chicago Press: September 1993— the essential reference for all who work with words.

Copyediting: A Practical Guide, by Karen Judd, Crisp Publications: October 1992—sound, practical advice about becoming an effective copyeditor.

Desktop Publishing & Design for Dummies, by Roger C. Parker, IDG Books Worldwide: January 1995—an easy-to-understand desktop reference for making any document professional and readable.

The Elements of Style, by William Strunk, Jr. and E.B. White; Allyn & Bacon: August 1999—a book that helps any writer become a better writer.

Getting It Printed: How to Work with Printers and Graphic Imaging Services to Assure Quality, Stay on Schedule, and Control Costs, by Mark Beach, North Light Books: March 1999—this excellent, well-written book explains both business and technical aspects of the printing industry to the layperson.

Pocket Pal: A Graphic Arts Production Handbook, Print Resource Group, Inc.: July 1997—covers all aspects of the graphics arts business including printing and electronic prepress; a great reference tool.

Teach Yourself Photoshop in 14 Days, by Bront Davis, et al., Hayden Books: July 1997—the essentials of Photoshop for beginners who want to learn quickly.

GLOSSARY

A

ad agency or advertising agency (page 14)—companies that consist of copywriters, graphic artists, production coordinators and free-lancers who create sales messages for print, radio, TV, e-media

annual global budget (page 7)—the amount of money allocated to cover all your print projects for a single year

ascenders (page 31)—parts of lowercase letters that are taller than the x-height

B

baseline (page 31)—the invisible line on which the type sits

basic size (page 74)—in the US and Canada, the standard size of sheets of paper used to calculate basis weight

basis weight (page 74)—in the US and Canada, the weight in pounds of a ream (500 sheets) of paper cut to its basic size

blanket (page 17)—a rubber-coated pad that is mounted on a cylinder of an offset press; the blanket receives the inked image from the printing plate and then transfers the image to the paper

bleed of color (page 106)—printing that extends to the very edge of the sheet; bleeds are created by trimming the sheet down to the printed area after the printing is complete and dry

block of color (page 106)—large areas of 100% color saturation

body copy (page 30)—all of the words that make up the main text of a printed piece; *not* part of any headings or display type

bond paper (page 71)—type of paper primarily used for duplicating and for writing paper for both business and personal correspondence; writing bond frequently contains a watermark

book paper (page 71)—type of paper suitable for catalogs, books, pamphlets; book paper comes in uncoated (also called offset paper) and coated

brightness (page 71)—a measure of the reflected light off the surface of paper; most papers rate between 60-90% brightness; brightness affects readability: too little brightness or contrast can make type difficult to read, too much brightness can cause eyestrain

bulk (page 71)—the degree of thickness of paper; in book printing, the number of pages per inch for a specific basis weight

bullets (page 26)—small graphic symbols or markers frequently used in a list instead of numbers; the lists in Table 6-2, page 101 start with bullets

C

calendering (page 78)—the process of making paper smooth by pressing it between rollers during the stages of the manufacturing process

camera ready (page 98)—mechanicals or laserprints that are ready to be shot by the printer's camera or platemaking system; camera-ready materials must be free of smudges, broken or faint type and screens of art/halftones must consist of reproducible dots

CD-ROM (page 123)—a compact disk which is used for storing and retrieving computer data

centered (page 34)—line of text that has the same amount of space from the left margin to the first typed character as it has from the right margin to the last character typed in that line

cheshire label (page 9)—a type of label that is printed on a wide carriage continuous form computer paper; cheshire labels are sliced, cut and applied with glue by a machine

coated both sides (page 73)—paper that has both sides of its surface treated with a clay coating; abbreviated as C2S

coated one side (page 73)—paper that is coated with clay on one side of the sheet and uncoated on the other; abbreviated C1S

coated paper (page 16)—paper that has been coated with clay; the coating makes the paper reflect more light and improves ink holdout

collateral (page 20)—printed materials that are used in tandem with each other for marketing, sales or communication

color quality (page 7)—the quality of ink laydown on the sheet; for flat colors, this term refers to consistency and saturation; for process colors, it refers to how close a match the printing reproduction is to the color of the original photographs or artwork

color-separated laserprints (page 98)—laserprints for a two-color print job; all black elements are printed on one laserprint, all color elements are printed on a second laserprint; these laserprints are registered together and printed with the selected ink colors to create the final printed piece

color separation (page 23)—technique of dividing continuous tone full-color images into four halftone negatives; the four films for black, cyan, magenta and yellow inks are created from this process

color swatch book (page 66)—a color tool that shows 100% strengths of Pantone Matching System colors on uncoated as well as coated papers; also called an ink swatch book or PMS book

color tint selector (page 68)—a book that shows how PMS colors will reproduce at different screen values on coated and uncoated papers (see page 69 for an example)

compositor (page 25)—*see typesetter*; historically the person who selected each individual letter and placed it face up in a composing stick, a box that would hold about a dozen lines of type

condensed type (page 26)—a narrow or slender typeface that fits more characters per inch than a regular face

contact screens (page 49)—flexible pieces of film with precision patterns of dots; a traditional method for creating a halftone

continuous forms (page 16)—forms that are preprinted on continuous-roll computer paper for use on office tractor-feed printers

continuous tone (page 48)—photographs and art that have a range of shades *not* made up of dots, as opposed to line copy or halftones

129

copyediting (page 36)—technical editing of a manuscript for spelling, grammar, punctuation and overall accuracy

copywriter (page 14)—the person who writes the text for advertisements or promotional material

corporate identity pieces (page 3)—materials that are imprinted with a company's logo, such as business cards, letterhead, presentation folders, etc.

cover paper (page 71)—thick paper that is suitable for business cards, book covers, presentation folders, etc.

CPU (page 117)—central processing unit of a computer

D

darkroom services (page 21)—services involving traditional graphic arts photography, such as halftones, PMTs, film stripping, and extended to include scanning and other prepress preparation

densitometer (page 61)—instrument used to measure color density for individual colors of a process color piece

descenders (page 31)—parts of lowercase letters that are below the baseline

design (page 3)—the arrangement of type, art, halftones, color, style of paper, etc. to produce a complete and artistic presentation of a message in print or electronic form

design elements (page 2)—type, rules, art, photos, bullets and graphic symbols, such as dingbats, that are used in tandem to create a finished design

desktop publishing (page 44)—the technique of using a personal computer and specific software programs to design images and pages, arrange type and graphics, and to output the assembled pages onto paper or film

die (page 18)—a manufactured mold used for cutting, scoring, stamping or embossing

die cutting (page 18)—to cut irregular shapes in paper using a die

direct mail (page 5)—letters or promotional material mailed directly to potential customers

dot gain (page 93)—the result of halftone dots spreading and printing larger on paper than they appear on films; this problem reduces the crispness of detail and lowers contrast

dots per inch/dpi (page 55)—measure of the resolution of input devices, such as scanners, and output devices, such as laserprinters and imagesetters

DSL (page 118)—digital subscriber line; high-speed bandwidth for transmitting digital information that is always on

dull (page 82)—flat (not glossy) finish on coated paper

duotone (page 59)—a two-color halftone reproduced from a black and white photograph; two halftones, one color and one black are shot at different screen angles and tonal values and then registered together to create a two-tone look

DVD (page 123)—digital versatile disk for high-speed storing, retrieval and transfer of digital information

E

ecospots (page 83)—recycled flecks, spots or fibers manufactured into the surface of recycled papers

embossing (page 18)—a process by which paper is pressed with special dies yielding an image that is higher than the original surface of the paper

EPS (page 121)—encapsulated postscript file; a digital file format for saving art and photographs

exact match color (page 108)—for process color, the highest quality color match available...not all presses can achieve this level of color match

expanded (page 26)—a type whose width is greater than normal

F

face trim (page 102)—the technique of trimming the edge of a bound publication so that the pages do not stick outside the cover

felt (page 81)—a type of finish that has a slightly bumpy texture

fiery (page 23)—color output generated from a computer disk that gives the client a representative idea how a final color piece will look

finishers (page 20)—the individuals who perform the final project tasks, such as die cutting, drilling, perforating, etc.

flat color (page 87)—any color created by printing only one ink; also called *spot color*, as opposed to process color

flush left (page 34)—the first character of each line of type aligns exactly at the beginning of subsequent lines of type

flush right (page 34)—the last character of each line of type aligns exactly to the last character for each subsequent line of type

foil stamping (page 18)—method of printing that releases foil from its backing when stamped with a heated die

font (page 26)—the specific size and design of a given typestyle including capital letters, lowercase letters, numerals, fractions, etc.

free-lancers (page 14)—people who are hired as individual contractors on a project by project basis

G

gloss (page 82)—a shiny or slick paper finish for coated paper; highly reflective

grade of paper (page 74)—term used to distinguish different types of printing papers from each other, such as different finishes or brands

grain (page 71)—in paper manufacturing, the direction in which most fibers lie, which corresponds with the direction the paper is manufactured on a paper machine

graphic artist/designer (page 14)—artists who specialize in preparing creative, reproducible designs that convey commercial messages

graphic arts photography (page 48)—the specialized darkroom techniques specifically for graphic arts reproduction, such as producing halftones and PMTs as well as film stripping, color separations and scanning

H

halftones (page 22)—black and white photos that have been converted from continuous tones to dot patterns so the printer can reproduce the images on press; a halftone creates the illusion of the original continuous tone photo

hexachrome (page 90)—a process that uses six color separations to create a more vibrant and broad color spectrum than process color; *see high-fidelity color*

hickey (page 84)—spot or imperfection in printing that is most visible in areas of heavy ink coverage; caused by dirt or lint on the printing plate or blanket

high-fidelity color (page 63)—color produced by using five or more color separations as compared to the four separations needed for process color

high-resolution images (page 118)—images that are very sharp on film, paper or other medium; as the resolution of an image increases, the visibility of its dot pattern decreases

house papers (page 78)—a line of papers that a printing house carries as their standard line; these papers may be less expensive because they are purchased in bulk by the printer

I

imagesetter (page 49)—laser output device that uses photosensitive paper or film

insert (page 8)—an item that is included within another printed piece, for example, an order form that is stapled inside a brochure or catalog

integral proof (page 92)—color proof of separations shown on one piece of photo paper as compared to an overlay proof

italic/oblique (page 26)—designates type with characters that slant upward to the right; italic type is used for emphasis and to designate book titles

J

justified (page 34)—the beginning and ending of each line of type is lined up exactly with the beginning and ending of each previous line of type

K

kerning (page 33)—tightens the space between two selected letters

knockout (page 106)—an area that is left white in a background image so that a foreground image can be printed in that space

L

laid finish (page 81)—a bumpy paper finish that contains grids of parallel lines

leading (page 30)—the space inserted between lines of type

letterpress (page 20)—method of printing using raised surfaces such as metal type or plates whose surfaces have been etched away from image areas

linen finish (page 81)—a finish that simulates the look of linen fabric; it is embossed into the paper surface during the manufacturing process

line screen (page 52)—*see lines per inch*

lines per inch/lpi (page 52)—the number of lines of output per inch; a halftone of 85 lines per inch is lower resolution than a halftone of 120 lines per inch; *lines per inch, lpi, line screen* and *screen frequency* are all synonymous

linotronic film output (page 23)—the film output produced by a computerized linotronic imagesetter; the film is produced from a graphic design saved on computer disk, as opposed to film produced by a traditional darkroom process

M

mailhouse (page 8)—a company that specializes in preparing printed material for mailing by affixing address labels, applying postage and sorting mail by zip code for delivery to the post office

markups (page 13)—amounts that are added to the cost to cover overhead and profit in order to arrive at a selling price

matte finish (page 82)—a somewhat nonreflective finish, often slightly roughened; refers to a specific finish for coated papers

mechanicals (page 15)—camera-ready paste-up of type, photos and line art all on one artboard

megabyte (page 118)—a unit of capacity equal to approximately one million bytes

megahertz (page 117)—one million hertz; a hertz is an international unit of frequency, equal to one cycle per second

metal plates (page 101)—metal surfaces that carry images to be printed; metal plates are shot from films and are desirable for long print runs with high-resolution images

mock duotone (page 59)—a halftone overprinted over a screen of color; a less expensive way to create an image similar in look to a true duotone

mock-up (page 5)—a model that shows how a final product should look; for example, to create a mock-up for a 16-page newsletter, you would take four 11 by 17 sheets, staple them together, position your printouts in the appropriate sequence and then mark any items that will be in color

moiré pattern (page 57)—the undesirable screen pattern caused by incorrect screen angles of overprinting halftones

multimedia (page 120)—a combination of media, such as video, audio, still shots, computer animation, special lighting effects, etc., used for education and entertainment; the term "multimedia" is frequently used for such computer presentations, stored on CD-ROM disks

O

oblique/italic (page 26)—*see italic*

offset lithography (page 17)—*see offset printing*

offset printing (page 17)—a method of printing by which an image is transferred or "offset" from an inked plate to a rubber blanket and then offset again to paper; a popular method of commercial printing because quality results are produced efficiently and economically

opacity (page 71)—characteristic of paper that prevents printing on one side from showing through to the other

orphan (page 36)—the first line of a paragraph that falls at the bottom of a column

overlay proof (page 92)—color proof that consists of film acetate sheets superimposed on each other with their images in register; for process color, a color overlay proof or color key would have a sheet of film for each of the four process colors

overprinting (page 106)—printing black or another dark color over a lighter color that has already been printed or is being printed at the same time

overruns (page 102)—the amount of overage printed for a specific print run

P

page imposition (page 104)—arrangement of pages on flats so they will appear in the proper sequence after printing and folding

page layout (page 22)—the design and structure of a page; how text and/or graphic images are placed on the page

parent size (page 76)—any sheet larger than 11 by 17 size

PDF (page 118)—portable document format; an electronic file that takes a "snapshot" of your original, which can then be transferred and output at a remote location

perfect binding (page 110)—a type of binding where the interior text pages are glued into the interior spine of a wraparound cover; the book you are reading is perfect bound

perforations (page 18)—dashed cut slits in paper, which make it possible to tear out a page or postcard

pica (page 30)—a typesetter's unit of measurement; one pica equals approximately 1/6 of an inch or 12 points

pixels per inch (page 121)—the number of basic units or picture elements in a square inch of a video or computer screen display

plastic comb binding (page 108)—a type of binding in which the teeth of a flexible piece of plastic are inserted into holes that have been prepunched into a collated sequence of sheets of paper

plate (page 17)—a paper, polyester or metal sheet that carries the image to be printed to the printing blanket

pleasing color (page 108)—color that is considered satisfactory to the customer even though it may not be an exact match to samples, objects or originals used in the reproduction process

PMS colors (page 17)—refers to Pantone Matching System colors; these colors, identified by a number system published by Pantone, Inc., are the standard flat colors used by the printing industry; this type of color matching system helps to eliminate confusion with color identification

PMT (page 59)—photomechanical transfer; a diffusion transfer process used to make positive paper prints of halftones and line copy, also called *photostat*

point (page 30)—a typesetter's unit of measurement used principally for designing type sizes; there are approximately 72 points to an inch

point size (page 30)—the measurement of a particular typeface which starts at the top of an ascender (the highest point of the character) and ends at the bottom of the descender (the lowest point of the character)

portfolio (page 14)—a collection of work by a graphic artist/designer to be shown as samples to prospective employers

postconsumer waste (page 83)—recycled fibers consisting of paper that was printed before, used for another purpose, then recycled

ppm (page 123)—pages per minute; refers to the speed of output devices

preconsumer waste (page 83)—recycled fiber that comes from material that was never printed nor used by the consumer, such as leftover paper scraps from paper manufacturing

prepress services (page 16)—any services needed prior to preparing materials for press—such as camera work, scanning, color separating, stripping, platemaking—completed by either a service bureau or printer prior to printing

press proofs (page 21)—advance samples of a print run, run off and checked by the client before the actual print run commences

printing brokers (page 13)—independent contractors who act as coordinators and intermediaries between clients and printers

print media (page 14)—anything produced on paper

print on demand (page 119)—refers to a type of short-run printing that can be produced in a rapid time frame after a document has been requested

process colors (page 17)—consist of cyan, magenta, yellow and black, CMYK; these colors are registered together to create the illusion of a full spectrum of color

production coordinator (page 14)—the person who keeps different aspects of a project on schedule and works with outside vendors throughout the various production stages of editing, writing, designing, printing and finishing

proofing (page 10)—carefully rechecking your work for errors in spelling, grammar, content, art labeling, art positioning and color quality

R

ragged left (page 34)—text is aligned at the right margin, the type to the left is not aligned and thus appears "ragged"

ragged right (page 34)—text is aligned at the left margin, the type to the right is not aligned and thus appears "ragged"

ream (page 74)—500 sheets of paper

recycled (page 71)—a type of paper that is manufactured from paper that was used before (see *preconsumer* and *postconsumer waste*)

registration (page 60)—to align printing properly with the edges of the paper or in relation to other printing on the same sheet

renderings (page 15)—drawings, sketches, or artist's depictions

reprographic services (page 23)—general term for xerography and other methods of copying used by designers, engineers, architects or for other office use

resolution (page 48)—sharpness of an image on paper or film

reverse-out type (page 30)—type that appears to be white on a background of black or color; it is created by knocking out the ink in those areas so that the color of the paper shows through

RGB (page 90)—stands for red, green, blue; the combination of RGB is used to create the colors displayed in computer monitors and television sets

roman type (page 26)—designates the upright style of most common printing types in modern use, as opposed to *italic*

rules (page 42)—lines which can have various point sizes or degrees of thickness

run (page 7)—the quantity that is printed

rush charges (page 8)—additional expense added to a job quote due to a compressed printing schedule

S

saddlestitching (page 108)—heavy-duty stapling, usually with a bookletmaker or a finishing unit at the end of a collator

sans serif (page 29)—typefaces that do *not* have ("sans" in French means without) little feet at the ends of the letter stroke

scanning (page 2)—converting images and continuous tone photo prints into digital information for the purpose of creating a halftone or other reproducible form of the image

scores (page 18)—straight indentations or grooves in paper that make it easier to fold

screen angles (page 59)—angles at which screens intersect with the invisible horizontal line of the press sheet; for process color, black 45°, magenta 75°, yellow 90°, cyan 105° form a rosette pattern which gives the illusion of full color

screened images (page 22)—images that have been halftoned or that contain a dot pattern or screen tint

screen frequency (page 52)—see *lines per inch*

screen tints (page 42)—created by dots rather than solid ink coverage; see page 69 for an example of different screen tints of the same ink color

self-mailers (page 3)—promotional or direct mail pieces that can be mailed without envelopes, such as postcards or brochures that are trifolded so that address labels can be placed directly on them

serif (page 29)—little feet at the ends of strokes of letters and numerals

set-up charges (page 7)—costs affixed to prepress preparation, such as preparation of plates, washing and inking of the press

sheet-fed (page 18)—a type of offset printing press that prints sheets of paper instead of rolls of paper

signatures (page 104)—printed sheets that are folded down several times and then gathered with others folded in the same way to make the interior of a book

silk screen printing (page 19)—the simplest form of all printing processes involving a screen stencil (made out of polyester, not silk), ink and squeegee; ink is forced through and the screen prints in the stencil's pattern; this method is used for products such as clothing, dishware, plastic, bottles, etc.

silvermaster plates (page 101)—polyester printing plates that are used for short-run, low-to-medium resolution printing

soft-sell (page 3)—selling that relies on subtle suggestion rather than high-pressure salesmanship

sort-tie-stack (page 9)—sorting by zip code, stacking in specified quantities and bundling pieces together for delivery to the post office

specification sheet (page 79)—the form or instructions you supply to the printer with all the specifications for an order or an estimate

spec out (page 97)—to specify all the relevant details of a printing job for the purpose of obtaining quotes

splash screen (page 120)—a visual that appears on the computer screen for a brief period of time during a multimedia or other computer presentation

spot color (page 87)—one ink applied to portions of the printed sheet; also called *flat color*, these colors come premixed or are mixed by the printer from the base Pantone Matching System colors

sticky-back labels (page 9)—labels that can be easily peeled off a sheet and affixed to direct mail pieces

stock (page 3)—synonym for paper

swatch book (page 66)—a book that shows samples of colors printed on coated and uncoated paper; used by the client for selecting and matching colors, used by the printer for ink mixing

T

text paper (page 71)—a grade of paper available in a wide variety of designer textures and colors

thumbnail (page 18)—a significantly reduced size of a page, as small as 10% of an actual page; a useful tool for page organization in a page layout program, such as QuarkXpress

tracking (page 33)—adjusting space between character pairs in the range of text selected

trapping (page 15)—overlapping ink to ensure that there is no space between two color images that abut; this result is achieved by making the image either slightly larger or slightly smaller with a camera or with page assembly computer software

trim size (page 102)—the final dimensions of a publication after it is face trimmed

typeface (page 26)—named type designs, such as Helvetica, Palatino, Garamond

type families (page 26)—all styles and variations of a particular typeface; for example, the Helvetica family contains plain, italic and bold styles

typesetter (page 25)—a person, firm or facility that sets type

typesetting (page 25)—*see typography*

typestyle (page 26)—refers to the form of the typeface; for example, "Roman" in any typeface means that the type stands straight up and down, whereas italic means slanted and script means an imitation of handwriting

typography (page 16)—the art or process of setting and arranging type for printing

two-color (page 7)—two colors designated as the colors used throughout a printed piece; for example, a print job that requires only blue and red inks is two-color, also, a job that requires black and red inks is two-color (black is considered a color)

U

uncoated papers (page 66)—papers that are *not* treated with a clay coating

V

varnish (page 20)—a thin, clear coating applied to a printed sheet for protection or appearance

vellum (page 80)—a type of paper finish that is slightly rough and stipled

vendors (page 21)—individuals who are contracted to provide a product or service, such as graphic designers, printers, embossers, etc.

W

watermark (page 71)—a name or graphic symbol that is manufactured into the surface of the paper

web (page 18)—a type of offset press which prints rolls of paper and yields either an 8-page or a 16-page, 8.5 by 11 booklet folded from one sheet cut from the roll after printing; (page 120)—refers to the world wide web, the digital information network

weight (page 71)—a major characteristic of paper; basis weight is determined by basic size, see p. 75 and Appendix A, p. 125

widow (page 36)—the last line of a paragraph that falls at the top of a column, see Table 3-11, p. 37

wire-o binding (page 108)—a type of binding that uses coils of wire that are inserted into prepunched holes; frequently used for software manuals so books lay flat

wove (page 80)—a paper finish with a slightly stipled surface

X

x-height (page 30)—the height of the main body of the lower case letter, the same height as the letter "x"

Z

zip (page 123)—iomega trademark for a type of storage disk that holds data equivalent to 70 floppy disks

INDEX

A

ad agency or advertising agency, 14
 hiring, 14
announcement envelopes, 89
annual global budget, 7
annual printing budget, sample of, 95
ascender, 31
audience, creating a target
 message for, 1

B

baseline, 31
basic size, 74
basis weight, 74
 for different paper grades, 75, 125
binderies, 23
bindery, types of, 111
blanket, 17
bleed of color, 16, 106
block of color, 106
body copy, 30
bond paper, 71
booklet envelopes, 89
book paper, 71
brightness, 71
budget, 6, 7, 8
 allocating, 8
 decisions on quantity relating to, 6
 in regard to printing, 6
bulk, 71
bullets, 26
business reply, 5

C

calendering, 78
camera ready, 98
catalog envelopes, 89
CD-ROM, 123
centered, 34
cheshire labels, 9
 versus sticky-back, 9
coated both sides/C2S, 73
coated one side/C1S, 73
 versus coated both sides, 73
coated paper, 16
collateral, 20
 final size of collateral, 5
color, adjustments to, 63
color, specifying, 104
color matching, on materials other
 than paper, 94
color processes, expense levels, 91
color proofing methods, 92-93
color quality, 7, 63, 90
 proofing methods to obtain, 92
 selection of paper in regard to, 63
color selection tools, 67-68
color-separated laserprints, 98-99
color separation, 23, 61- 62
 registration of, 61-62
color swatch book, 66
color terminology, 106-107
color tint selector, 68-69
column widths, 35
commercial envelopes, 88
competitive materials, how to
 create a file of, 3
competitors, 4, 6
 analyzing your, 6
 distinguishing your company from, 4
compositor, 25, *also see typesetter*

condensed type, 26
contact screens, 49
continuous forms, 16
continuous tone, 48
 versus halftone, 48
copyediting, 36
copyediting marks, 36, 38-41, *also
 see proofreading marks*
copyright permission, 57
copywriter, 14
corporate identity pieces, 3
cover paper, 71
CPU, 117
cross cut, 76

D

darkroom services, 21
densitometer, 61
descender, 31
design, 3
 customizing, 121
 using in different ways, 119-120
design elements, 2
 selecting to match tone, 42-43
 supporting your sales message, 2
designer, 3, 15
 choosing a, 15
 evaluating a portfolio, 3
desktop publishing, 44
 resources for, 45
die, 18
die cutting, 18
direct mail, 5
disk files, supplying to vendors, 101
dot gain, 93
dots per inch/dpi, 55
 laserprinter versus scanner, 57
 setting for scanning, 58
 versus lines per inch/lpi, 55-56
DSL, 118
dull, 82

duotone, 59, 106
 versus mock duotone, 59-60
DVD, 123

E

ecospots, 83
electronic files, sending, 118-119
embossing, 18
envelopes, 86, 88-89
 custom versus standard, 86
 styles of, 88-89
EPS, 121
equivalent weights, 75, 125
exact match color,108
expanded, 26

F

face trim, 102
 versus not face trimmed, 103
felt, 81
fiery, 23
films, needed for process color, 98
finishers, 20
 selecting, 20
flat color, 87
 versus process color, 87
flush left, 34
flush right, 34
foil stamping, 18
folds, types of, 109
font, 26, 27
free-lancers, 14

G

gloss, 82
grade of paper, 74
grain, 71

146

147

process color, 17, 61-62, 87
 versus spot/flat color, 87
production coordinators, 14
project, planning and
 scheduling, 10-11
proofing, 10
proofreading, 3
proofreading marks, 36, 38-41, *also
 see copyediting marks*

Q

quantity, 7, 102
 guaranteed, 7
 specifying, 102
 versus budget, 7
quotation request, sample of, 112-115

R

ragged left, 34
ragged right, 34
ream, 74
recycled, 71
 appropriate project match for, 84
 versus nonrecycled, 83-84
registration, 60
renderings, 15
reprographic services, 23
resolution, 48
reverse-out type, 30-31
RGB, 90
 versus CMYK, 90
roman type, 26
rules, 42
run, 7
rush charges, 8

S

saddlestitching, 108
sales message, 1-2

sans serif, 29
scanning, 21
 methods for preprinted halftones, 57
scores, 18
screen angle, 59
screened images, 22
screen frequency, 52
 selecting appropriate, 53
screen tints, 42
self-mailers, 3, 5
serif, 29
set-up charges, 7
sheet-fed, 18
 versus web, 18
shipping instructions, 110
signatures, 104
silk screen printing, 19
silvermaster plates, 101
soft-sell, 3
software, 44, 100
 for page layout, 44
 vendor compatibility, 100
sort-tie-stack, 9
specification sheet, 79
specifications, to obtain
 quotes, 97-115
spec out, 97
splash screen, 120
spot color, 87
 versus process color, 87
sticky-back labels, 9
 versus cheshire, 9
stock, 3
swatch book, 66
 using a, 66

T

text paper, 71, 73
 versus cover, 74, 76
thumbnail, 18

tools for color selection, 67-68
tracking, 33
trapping, 15, 18, 106-107
trim size, 102
type, 29, 42
 choosing for body copy, 29
 tone of, 42
type alignment, styles of, 34
typeface, 26
type families, 26-27
 distinguishing features of, 28
 same sentence in different, 27
typesetter, 25
typesetting, 25, *see typography*
 history of , 25, 26
typestyle, 26
 different typestyles for same, 27
typography, 16, *see typesetting*
two-color, 7

U

uncoated papers, 66
 versus coated, 66

V

varnish, 20, 108
vellum, 80
vendors, 20-21
 ensuring communication, 20

W

watermark, 71
web press, 18
weight, 71
widow, 36
 correcting by tracking, 36-37

window envelopes, 88
wire-o binding, 108, 110
world wide web, 120
wove, 80

X

x-height, 30

Z

zip, 123